50 Gems
of
Norfolk

PETE GOODRUM

AMBERLEY

For Gloria and John

First published 2017

Amberley Publishing
The Hill, Stroud
Gloucestershire, GL5 4EP

www.amberley-books.com

Copyright © Pete Goodrum, 2017

Front cover photograph of Wells Beach Huts is courtesy of Daniel Tink.

Back cover photograph of Happisburgh is courtesy of Roots and Toots Blog.
www.rootsandtoots.com

Map contains Ordnance Survey data © Crown copyright and database right [2017]

The right of Pete Goodrum to be identified as the Author
of this work has been asserted in accordance with the
Copyrights, Designs and Patents Act 1988.

British Library Cataloguing in Publication Data.
A catalogue record for this book is available from the British Library.

ISBN 978 1 4456 5727 1 (print)
ISBN 978 1 4456 5728 8 (ebook)

Map illustration by User Design, Illustration and Typesetting.

Origination by Amberley Publishing.

Printed in Great Britain.

Contents

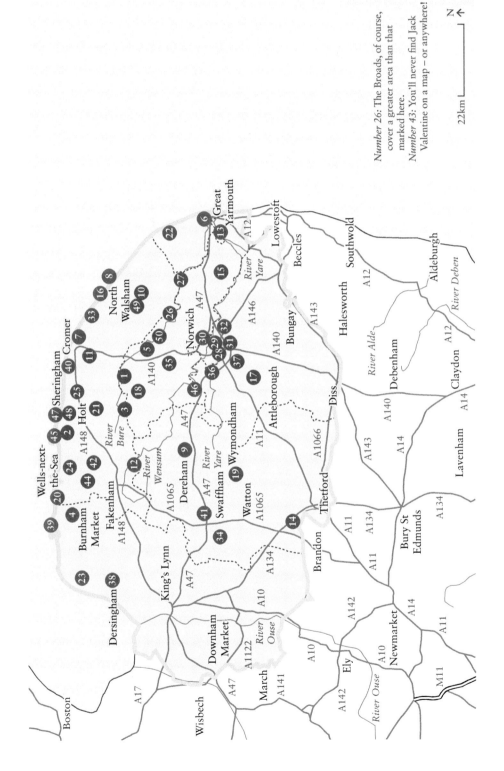

Number 26: The Broads, of course, cover a greater area than that marked here.

Number 43: You'll never find Jack Valentine on a map – or anywhere!

22km

N

Introduction

I suppose that everyone believes that the county of their birth, or their adopted home, is unique. They're probably justified, because one of the great joys of Great Britain is the huge variation in scenery, landscape, history and occupations across our counties, making each one of them special.

For me, Norfolk is home, and a very special place. I love the city of Norwich, the towns and villages, the coastline and the countryside. I love the Broads, the wide Norfolk skies and quiet backwaters.

I'm constantly fascinated by, and am always learning about, the county. Norfolk has a pivotal role in the country's agricultural history and an often underestimated place in our commercial development.

This great county is a treasure chest full of jewels to be discovered by natives and visitors alike. I've chosen fifty of them. They are eclectic, as befits the county, but of course could never be definitive. They're also a personal selection, and so may contain some unexpected entries and indeed miss some that others thought worthy of inclusion. It would prove difficult to gain universal agreement. It was certainly difficult to refine the possible list to just these fifty.

I've selected my 'fifty gems' by choosing places, people, and sometimes intangible aspects, because they interest me and I hope will interest others. I've chosen them because they say something about Norfolk and because they represent the diversity, splendour, past, present, people and, yes, magic, of Norfolk.

I've presented them alphabetically (mostly), partly to make the book easy to navigate and because it seemed the fairest method. This is, as I said, a very personal selection!

My choices are an insight into Norfolk and what makes it unique. I hope you enjoy them. I hope you visit them. They are fifty gems of Norfolk.

Pete Goodrum
February 2017

Chapter 1

1. Aylsham

The lovely market town of Aylsham is somehow greater than the sum of its parts. Instantly appealing, and more than pleasant to look at, it has both an interesting history and a vibrant present.

Even the town sign has a story to tell. It features John of Gaunt, who was lord of the manor in 1372. He's no less than the John of Gaunt who appears in Shakespeare's Richard II, and his deathbed speech is one of the most famous in English theatre. He's the character who says the immortal lines:

> This royal throne of kings, this sceptred isle,
> This earth of majesty, this seat of Mars,
>
> This happy breed of men, this little world,
> This precious stone set in a silver sea.

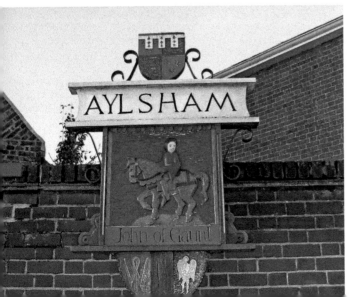

Aylsham town sign. (Courtesy: www.tournorfolk.co.uk)

John is not the only literary connection to Aylsham. The Black Boys Inn is one of Aylsham's oldest surviving buildings. It's been on the site since the 1650s, although the present frontage dates to between 1710 and 1720.

The inn stands in the market square with its fine eighteenth-century houses evidencing the town's prosperity at the height of the cloth trade in Norfolk.

Time was that the Black Boys Inn was a stop for the stagecoach carrying mail from Norwich to Cromer, and it had stabling for forty horses. Among its famous guests have been Daniel Defoe, author of *Robinson Crusoe*, who stayed and dined at the inn in 1732. A little later, in 1781, the Black Boys was host to Parson Woodforde, the legendary diarist.

Less of a literary connection, but a vital character in Norfolk's history, is Lord Nelson, who had a cousin living in Aylsham. Nelson is recorded as having danced in the Assembly Room, near to the inn.

Such a history of wining and dining has laid the foundations for Aylsham having become a favourite destination for food lovers today. It's a town with award-winning food outlets. Aylsham also holds FARMA-accredited farmers' markets and an internationally recognised food festival.

When it comes to shopping for food, Aylsham has another claim to fame. Paying for your plastic carrier bags might seem a relatively recent innovation, but Aylsham was ahead of the game, becoming Norfolk's first plastic-bag-free town in May 2008. In truth it did prove a little difficult to implement but it was a creditable and early introduction of something now much more widely practiced.

The Black Boys Inn, Aylsham. (Courtesy: www.tournorfolk.co.uk)

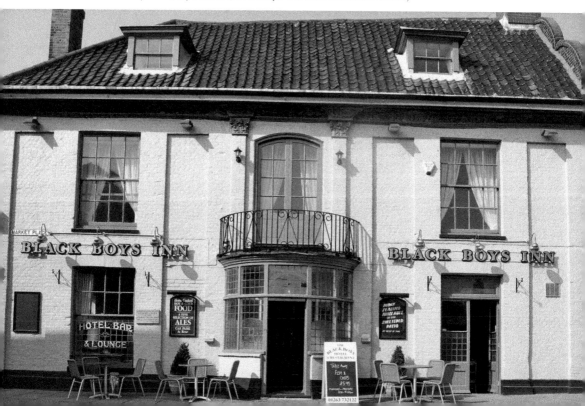

On environmental matters, Aylsham scores again. The Tesco store in the town is built from wood, recyclable plastic and other sustainable materials, and was claimed to be the 'greenest' in the world when it opened in July 2008.

Three years earlier Aylsham had made another appearance on the world stage. The town came fourth in the world in an international competition celebrating liveable communities, winning a silver award in Category A (towns with a population up to 20,000) of the International Awards for Liveable Communities, held in Spain in 2005.

Aylsham is proud of its history and boasts a heritage centre, which is housed in rooms in the grounds of the fourteenth-century St Michael's Church. The centre contains a lot information and artefacts, some dating back to Roman times.

Easily accessible, and situated by the upper reaches of the River Bure, Aylsham is both a popular town to visit and a sought after place in which to live.

2. Blakeney

Justifiably part of the Norfolk Coast Area of Outstanding Natural Beauty, Blakeney is a real gem of north Norfolk.

Historically it can be traced back to the Domesday Book, and we know that, earlier names aside, it was listed as Blakeney as early as 1340. It's said that in the fourteenth century Queen Philippa, wife of Edward III, dined on fish caught by the fishermen of Blakeney. The village would remain as a seaport until the twentieth century, but silting up of the area now means that only the smallest of craft can navigate their way beyond Blakeney Point and out to sea.

Blakeney. (Courtesy: www.tournorfolk. co.uk)

Blakeney. (Courtesy: www.tournorfolk.co.uk)

It was other local ports silting up before Blakeney that allowed it to prosper. The seventeenth century saw it begin to grow, until in the 1800s there were packet ships sailing from here to London.

In earlier days the commerce of Blakeney was somewhat less legal: piracy was rife in the 1300s, with foreign ships often being sailed back to Blakeney to be stripped of their cargoes. So lawless was the place that Blakeney refused to supply a ship to help fight the Spanish Armada.

The village boasts an impressive church. St Nicholas has two towers. The main one is over 100 feet (30 metres) high and a well-known landmark for miles around; the smaller tower was built to serve as a beacon, guiding boats into the harbour. Other places of interest include the Guildhall with its fourteenth-century undercroft and Mariners Hill, which is believed to be man-made, probably as a lookout place for the harbour.

Like many places in Norfolk, Blakeney has a place in railway history. Here, though, it's an odd footnote. In the nineteenth-century railway mania it was intended to build a branch line between Holt and Blakeney, where a new station was to be built. The plan was never brought to fruition.

Blakeney is a place of the pretty flint cottages that typify north Norfolk, and a favourite spot with people both from the county and further afield. There are two hotels and the area is ideal for birdwatching, fishing and the ever-popular north Norfolk pastime of crabbing.

3. Blickling

Situated to the north of Aylsham, Blickling Hall really is a stately home. Built in 1616, its history is full of legendary names. First among them is the man who owned it in the fifteenth century, and whose coat of arms can still be seen there – Sir John Fastolf of Caister in Norfolk. He died in 1459 but his name and reputation will live forever as the inspiration for Shakespeare's Sir John Falstaff. In fact should he not have been enshrined in literature, he would still have been famous. He was an established writer and a notable soldier, who became extremely rich during the Hundred Years' War.

From around 1499 the house was occupied by a family with another name etched into history: Thomas Boleyn lived there with his wife Elizabeth. There is some debate over the dates of the births of their children, although it seems possible that all three were born at Blickling. The eldest, Mary, is likely to have arrived around 1500 and the youngest, George, in 1504. Between them came the girl who would achieve such unwelcome fame – Anne.

An inscription on a statue of Anne at Blickling states '*Anna Bolena hic nata 1507*' ('Anne Boleyn born here 1507'). It's generally recognised now that the date is wrong. Some scholars argue that if she was born after 1505 it's possible she was not born at Blickling.

Blickling Hall. (Courtesy: Roots and Toots Blog, www.rootsandtoots.com)

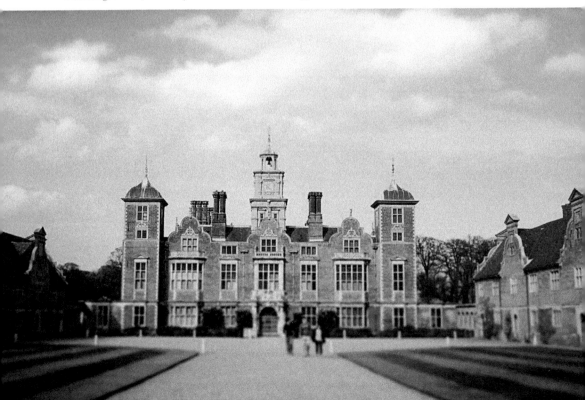

Born there or not, she seems to have returned to Blickling quite regularly. It's said that on the anniversary of her execution a carriage pulled by headless horses arrives at Blickling. The equally headless coachman reins in his steeds. From the coach steps Anne, who wanders the house carrying her severed head. All night she walks the rooms and corridors before disappearing when dawn breaks.

It's impressive that her ghost knows its way around, because the house that she lived in has long gone. The present hall stands on the location of the old Boleyn house but wasn't built until the site was bought by Sir Henry Hobart in 1616, some eighty years after Anne's execution in 1536!

It's this great Jacobean house that is Blickling Hall today. A house that remained in private hands until 1940 when it came under the care of The National Trust. Its owner, Philip Kerr, the 11th Marquess of Lothian, died and bequeathed it. Soon after this, during the Second World War, the house was requisitioned and became the officers' mess for RAF Oulton. Officers were also billeted in Blickling Hall while lower ranks lived in Nissen Huts in the grounds. Such was the connection with RAF Oulton that the house still contains a museum, a tribute to crews who served there during the war.

Post-war the house was let, and tenants occupied it until 1960 when the National Trust embarked on an ambitious scheme of restoration, with the aim of embracing its history. By 1962 the 'Blickling estate' was open to the public, as it is today.

Blickling is a startlingly handsome house and it has had its photogenic qualities put to good use over the years. In 1945 it appeared as 'Maryiot Cells' at 'Maiden Worthy' in the classic movie *The Wicked Lady*. It was used in a music video by Charlene for her 1982 hit 'I've Never Been to Me', and in 2002 Blickling featured as Bono's house in a TV program called *I Know What Alan Did Last Summer* featuring that other gem of Norfolk – Alan Partridge.

Questions about the veracity of those ghostly visits by Anne Boleyn aside, another of Blickling's claims to fame is that in 2007 a National Trust survey voted it 'the most haunted house in Britain'.

Blickling is a big estate and contains many treasures. Inside the house the library is of international importance. Among its manuscripts are the Blickling Homilies, considered to be some of the earliest known, and certainly earliest existing, examples of this style of religious writing.

Outside, the estate's 4,777 acres include woodlands, prime agricultural land, which is farmed to deliver income for the estate, parkland and the garden.

The garden at Blickling has a long history and is a wonderful part of this important estate. Not much is known of the gardens before Sir Henry Hobart remodelled them after his 1616 purchase. But from that point on Sir Henry created ponds and a 'wilderness' as well as an artificial mound to give a better view of it all. In the eighteenth century Sir John Hobart set about a programme of works to create groups of trees in natural arrangements. The orangery was added in the 1780s and when Hobart died in 1793 his daughter carried on the work by employing the last of the great English eighteenth-century gardeners, Humphry Repton.

The history moves in leaps and bounds from there. Such are the oddities of successions that in 1840 the estate was inherited by William Schomberg Robert Kerr, 8th Marquess of Lothian. He was nine years old. Having inherited young, Kerr also died young – at the age of thirty-eight. During his short life he did restore some of the formality to the garden's design.

By 1930 Blickling had passed to Philip Henry Kerr, 11th Marquis of Lothian. Kerr was 'high profile' to say the least. He had a successful political career, with roles that include secretary to Prime Minister Lloyd George. He was active in attempts to avert the Second World War and met Adolf Hitler twice to try to negotiate peace. By 1939 he was ambassador to the USA and worked closely with Churchill to secure American aid for Britain's looming war effort.

Socially, he was part of the fashionable group known as the Cliveden Set and during the 1930s at Blickling he entertained figures ranging from Stanley Baldwin and Nancy Astor (the first female MP) to showbiz personalities including Joyce Grenfell, and even the German Ambassador, Joachim Von Ribbentrop.

Blickling attracted some adverse comments in *Country Life* magazine and Kerr employed the socialite gardener Norah Lindsay to change things.

With considerable foresight he addressed the National Trust's annual meeting and urged them to form a Country House Scheme as he believed that the great houses should be protected for the greater good. 'I venture to think', he said, 'that the country houses of Britain with their gardens, their parks, their pictures, their furniture and their peculiar architectural charm, represent a treasure of quiet beauty…'

True to his beliefs, when he died in 1940 he bequeathed Blickling, the majority of its contents and the estate to the National Trust, endearingly including in his will that it was 'subject to regular access by the public'.

Blickling. (Courtesy: Roots and Toots Blog, www.rootsandtoots.com)

Today the gardens are visited by thousands every year. Blickling plays host to outdoor concerts and Christmas fairs. It's a house with history, and has engaged with the twenty-first century to be accessible and enjoyable.

4. Burnham Thorpe and 'The Burnhams'

Burnham Thorpe is just one of the group of villages known as 'the Burnhams'. They are, in full, Burnham Deepdale, Burnham Norton, Burnham Sutton, Burnham Thorpe, Burnham Overy, Burnham Ulph and Burnham Westgate. These seven villages were presumably those referred to in a rhyme from the Middle Ages that said:

> London, York and Coventry
> And the Seven Burnhams by the Sea

This would indicate that the villages were in some way important at that time. It's not wholly surprising that Norfolk should have been seen so, as we know eighteenth-century Norwich was second only to London; it was the richest provincial city in England and capital of a populous and prosperous county. And yet, as far as we know, the 'seven' referred to were the seven listed above; a list

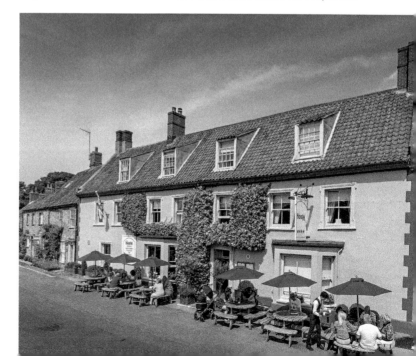

The Hoste Arms,
Burnham Market.
(Courtesy:
The Hoste.)

that doesn't include what is now the largest of the group, Burnham Market. The reason is that Burnham Market as we know it today is a 'merging' of the old Burnham Sutton, Burnham Ulph and Burnham Westgate.

Burnham Market is perhaps the best known of the villages today. It's a sought-after place for both holidays and full-time residences. The name suggests that there was a market, and that's thought to be the result of Burnham Market being a centre in the once important amber trade. The market has gone, but lives on in the name of this stylish village. The Hoste Arms, named after Captain William Hoste, is a favourite spot for locals, visitors and the significant number of people with a second home there.

All of the Burnhams are in the valley of the River Burn, and indeed close to the sea. And the sea has a very important connection with Burnham Thorpe. There's a clue in the saying, or mnemonic, once taught to help people remember the names of the seven Burnham villages. The chant to jog memories of Burnham Norton, Thorpe, Deepdale, Westgate, Ulph and Sutton was: 'Nelson of Thorpe Died Well Under Sail.'

Burnham Thorpe was the birthplace of Britain's most famous naval hero. Vice Admiral Horatio Nelson, 1st Viscount Nelson, was born in the village's parsonage in 1758. He would live there again, with his wife, from 1786–93 as he waited to be assigned to a ship. But, long before his illustrious naval career took shape, this Norfolk boy, later a national hero, learned to sail on nearby Barton Broad.

Nelson's achievements, culminating in the Battle of Trafalgar, which alone has earned him an indelible mark in history, are legendary. He is understandably

Barton Broad. (Courtesy: www.tournorfolk.co.uk)

Burnham Church. (Courtesy: www.tournorfolk.co.uk)

remembered in Burnham Thorpe; the building in which he was born has long gone, but a plaque marks the spot.

His father was rector at the church there, and when All Saints Church was restored much later in 1890, the admiralty provided wood from Nelson's legendary flagship HMS *Victory* to be used in the works. The lectern and rood screen were made from it. Also, inside the church are a bust of Nelson and flags from his ship. His parents' tombs are in the chancel of the church.

As in many a village, there's a pub near the church. The Lord Nelson still has the feel of an inn of Nelson's time – he did indeed spend time there. Often drinking in the inn, he is also reputed to have dined there to celebrate upon hearing that he had been awarded the command of HMS *Agamemnon*. This leads to another connection to the Burnhams.

The popular hotel and restaurant in Burnham Market is known as the Hoste Arms, and takes its name from Captain William Hoste. The young William Hoste started his naval career as Nelson's servant on HMS *Agamemnon* when he took the command in 1793. He seems to have become something of a favourite of Nelson, who mentioned him in his letters as 'one of the finest boys I ever met with'. Hoste impressed Nelson with his 'gallantry', and was promoted by him to midshipman in 1794.

This other Norfolk boy would also have a notable time in the navy. Although not at Trafalgar, he obtained a reputation as one of the outstanding frigate captains of

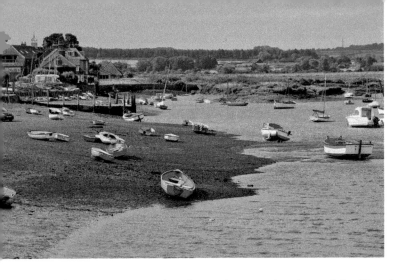

his generation, and took part in several actions of the Napoleonic Wars. Knighted in 1815, he married Lady Harriet Walpole and went on to be assigned to the royal yacht *Royal Sovereign*. He died of tuberculosis, in London, in December 1828.

Perhaps now, in the shadow of Nelson, it's fitting that he too is remembered in the villages of Burnham – a small part of rural Norfolk that produced two such important characters in our naval history. Some of the Burnhams may be better known than others, and there are differences between them. But they are real Norfolk villages and they are directly linked to national history.

5. Buxton

Even the village sign reflects the long connection to milling at Buxton, which is wholly appropriate because the mill dates back to 1085 at least, and we know that it was rebuilt in 1754. It actually ceased being a mill in 1970 and since then has been a restaurant, a hotel, and is now residential properties.

In the nineteenth century the Great Eastern Railway ran through Buxton, which had its own station. Nowadays it has just a 'halt' but it's still working, thanks to the Bure Valley Railway.

Buxton's often quoted claim to fame is of being the home and final resting place of Anna Sewell, the author of *Black Beauty*. In truth the claim is not entirely justified, as she is buried in the grounds of the old Quaker Meeting House at Lamas, the neighbouring village.

Buxton and Lamas are actually separated by the River Bure but form one civil parish. It was the Bure that powered the mill. Just 8 miles from Norwich, Buxton is a quiet place today. It's a Norfolk village with real history. In a slightly spooky link to Blickling, it is said a ghostly coach carrying Anne Boleyn's father crosses the bridge here on every anniversary of her execution.

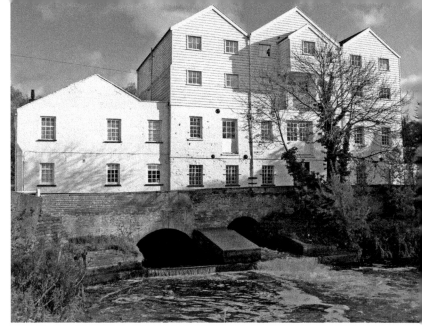

Buxton Mill.
(Courtesy: www.
tournorfolk.co.uk)

6. Caister-on-Sea

Caister-on-Sea deserves a place in this collection of Norfolk gems for its very special part in maritime history.

A neighbour to Great Yarmouth and a holiday resort in its own right, Caister has a long history. The Romans built a fort here for their army and navy around AD 200, the excavated remains of which are open to the public and well worth a visit.

Caister is also home to Great Yarmouth Racecourse, which is a popular venue with locals and holidaymakers. The beach is as sandy and wide as you'd expect in Norfolk. As a holiday destination it has quite a history too. The caravan and holiday park there dates back to 1906, making it one of the oldest in the UK. But it's the lifeboat that has earned such an important place in the county's history. Caister-on-Sea has been the home of an offshore lifeboat since 1791. Run by a private company, it was, in those early days, often used to gather salvage from shipping wrecked on the sandbanks. In 1856 the RNLI took over the operation of the lifeboats at Caister. Less than fifty years later, in 1901, the Caister-on-Sea lifeboat men would write themselves into history.

13 November 1901 was a day of bad weather. The sea was perilous in a gale-force wind and heavy rain. Just after 11 p.m. that night flares were seen from a ship in distress. It was on the sandbanks. Attempts were made to launch *Beauchamp*, the Caister lifeboat. In treacherous conditions the launching crew tried and tried again until finally she was afloat. It was 2 a.m.

Caister lifeboat.
(Courtesy: Caister
Lifeboat and
Blackwell Print.)

Seventy-eight-year-old James Haylett, who had been coxswain, and now had two sons, a son-in-law and two grandsons in the boat, remained on watch. He was soaked and tired.

The *Beauchamp* was a non-self-righting boat. At 36 feet long and 10.5 feet wide, she weighed 5 tons without her gear. Fully crewed and equipped, with her ballast tanks full, the boat needed thirty-six men to haul her on to the beach.

But on that night it was the sea that propelled *Beauchamp* on to the beach. They'd steered towards the wrecked vessel but had been driven back by the storm and hit the sand, bow first, 50 yards from where they'd launched. It was 3 a.m.

Frederick Haylett, who returned now to the beach after running home to change out of his sodden clothing, shouted to the elderly James, alerting him to the cries coming from *Beauchamp*, which now lay uppermost in the crashing surf. The crew were trapped beneath the boat. Between them the Haylett men pulled out James' grandson Walter, his son-in-law Charles Knights and another crew member, John Hubbard. They were the only survivors.

In daylight eight more bodies would be found. A ninth, that of Charles Bonney George, had been washed away and was only recovered in the following April. In a single night Charles Bonney George, Aaron Walter Haylett, the Coxswain, James Haylett Jnr, William Brown, Charles Brown, William Wilson, John Smith, George King and Harry Knights had perished.

At the inquest there were questions, and when asked by the coroner if the crew 'had given up the job and were returning', James Haylett replied: 'They would never give up the ship. If they had to keep at it 'til now, they would have sailed about until daylight to help her. Going back is against the rules when we see distress signals like that.' It was that phrase which when, in truth, inaccurately reported by the press, became famous as 'Caister men never turn back'. It's a phrase that's gone on to embody the spirit of lifeboat men throughout the RNLI.

James Haylett would meet the king, Edward VII, in 1902 and be awarded the RNLI gold medal. *Beauchamp* never went to sea again.

In a fitting footnote to the spirit of Caister lifeboat men, when the station was closed by the RNLI in 1969 it was reopened as an independently run operation and continues to this day, saving lives and always on call.

7. Cromer

Cromer had to be included among these fifty gems of Norfolk for many reasons, but most of all because it is a self-proclaimed 'Gem of the Norfolk Coast'.

While its early history stretches back to certainly the thirteenth century, and it was probably already known as Cromer by the fourteenth century, it's the 1800s that brought the town into focus with its emergence as a resort.

Part of the area that would become known as 'Poppyland', thanks to the writings of Clement Scott, Cromer became a favourite place to be for not only the wealthy bankers and industrialists of Norwich, but also well-heeled visitors from further afield, including London.

It was a fun place to be and decidedly fashionable – the future Edward VII liked to play golf there. Unsurprisingly hotels sprung up to accommodate the new tourists, ferried there by the growing railway network. The seaside residence of Lord Suffield was converted into the Hotel de Paris in 1830 – when it was only ten years old – by Pierre le Francois, and subsequently modified by Norfolk architect George Skipper.

The Red Lion was also a rebuilding of a former establishment; the hotel was constructed in the 1880s. Soon after that George Skipper was at work again, remodelling the façade of the Cliftonville Hotel into the popular Arts and Craft style. Of foremost importance in Cromer's architecture, and a vital part of its history as a resort, is the pier.

Cromer Pier was there long before the arrival of piers as a place of holiday pleasure. Records show there was a jetty in place as early as 1391, and it's a matter of record that in 1582 Elizabeth I sanctioned the use of income from Cromer's wheat and barley export to be used for the maintenance of the town and its pier.

Cromer. (Courtesy: the Norfolk Coast Partnership.)

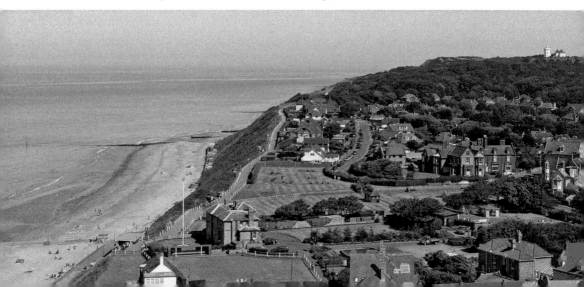

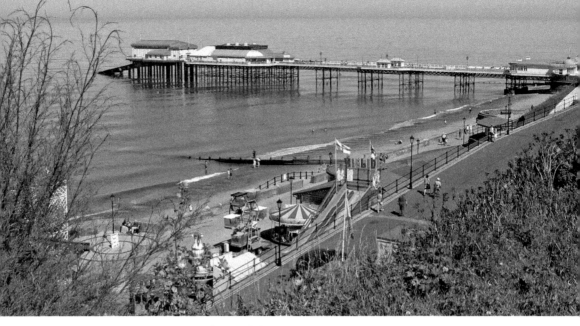

The pier, Cromer. (Courtesy: the Norfolk Coast Partnership.)

An iron jetty, or pier, was built in the early 1820s but it was destined to last for only twenty-four years, when it was destroyed in a storm. It was the next structure, this time mainly of wood again, that saw the arrival of promenading, or simply strolling, on the pier for pleasure. At 240 feet long it was the 'in place' for nineteenth-century holidaymakers who, nonetheless, had to abide by certain rules. Smoking – hugely popular at the time – was banned on the pier and ladies were required to absent themselves from it by 9 p.m. An official pier keeper watched over it to ensure the rules were upheld.

In 1897 a coal boat crashed into the pier. It was beyond repair and its timbers were sold off for £40.

Cromer, it seemed, had to have a pier, and the replacement was built in 1902. Designed by Douglass & Arnott and built by Alfred Thorne, this was the epitome of Edwardian seaside splendour. At 450 feet long with decorative metal construction, glass shelters and a bandstand, it cost a staggering £17,000. By 1907 it was the centre for the Edwardian's latest craze – roller skating.

Over the years Cromer Pier has been damaged and restored more than once. Terrible damage to the pier and seafront was sustained on 5 December 2013 when the town was hit by a massive storm surge.

It is home to a real end of the pier show and was voted Pier of the Year, 2015. It's also a favourite place for crab fishing.

Cromer crabs are important to the town. Famous for having more white meat than dark and legendarily tender, they are justifiably known as a speciality. In fact the fishing industry in Cromer is now all but totally based on crabs. The days of catching crab only in the summer, while the autumn and winter months were for longshore herring and cod, are gone. So, too, are the scores of boats that worked from the beach. But a dozen or so Cromer crab boats still set out from the east beach, and still they stock the fresh crab shops in the town.

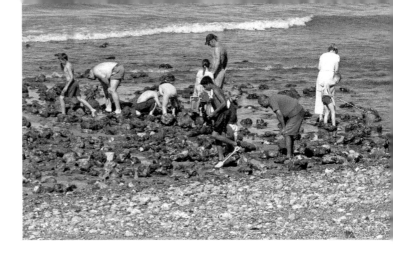

Crabbing at Cromer. (Courtesy: www. tournorfolk.co.uk)

Always watching out for the safety of fishermen, and everybody else, are the lifeboat crews; Cromer is another Norfolk town with a proud RNLI history. Near to the pier is the Rocket House, home to the RNLI Henry Blogg Museum. It celebrates the boats, crews, and in particular the rescues and heroism of Norfolk's most famous lifeboatman, Henry Blogg.

Blogg is a giant of lifeboat history. He stands as perhaps Britain's greatest lifeboatman. Born in Cromer in 1876, he was a fisherman and ran a deckchair business. The lifeboat, though, was in his family and in his blood. His exploits include the rescues of the *Pyrin* and the *Fernebo* in 1917, and the SS *English Trader* in 1941. He was awarded the Royal National Lifeboat Institution's gold medal three times, and its silver medal four times. Aside from the Institution's own medal he was also decorated with the George Cross and the British Empire Medal.

Henry Blogg died in 1954, but the Cromer Lifeboat has carried on the tradition of being there for those in danger at sea. The town he loved has gone on to be an even more popular holiday destination. Every August it hosts Carnival Week, drawing ever-bigger crowds to the north Norfolk coast. In May, the Cromer & Sheringham Crab & Lobster Festival brings together the two towns in a celebration of the area's famous shellfish.

Cromer is still the lovely seaside town it's always been, but nowadays it's part of a north Norfolk that celebrates art, literature, music, heritage – and good food.

8. The Deep History Coast

Grimes Graves (of which more later) is, they say, an opportunity to climb down into Norfolk's ancient past. The 'Deep History Coast' is a chance to walk in the footsteps of some of our earliest ancestors. Literally.

Footprints found at Happisburgh clearly prove that humans were there over 850,000 years ago. The prints are the oldest evidence we have of humans

Left: The Deep
History Coast.

Below: Happisburgh – a
key site for the Deep
History Coast. (Courtesy:
the Museum of the Citizen,
British Museum.)

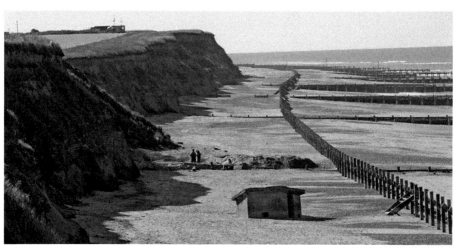

anywhere outside of the Great Rift Valley in Africa. Sometimes, because of this
proof of such ancient inhabitation, this area of Norfolk is dubbed the 'Cradle of
Civilisation'. It's also known as the 'Deep History Coast', taking the name from
the fact that it is seen by historians as the earth's equivalent to deep space.

 The Deep History Coast is an initiative centred on the coastal strip between
Happisburgh and Weybourne. It is a beautiful part of Norfolk's coastline, but it's
impossible to overstate its historical importance. It includes the most important
archaeological site in Western Europe, as well as the best preserved Neanderthal
site in the UK. And Norfolk is the only county where evidence of four species of
human have been found.

The footprints at Happisburgh are an amazing find. They have uncovered so much about these ancient people. Specialist 3D photography was used and revealed the prints of their heels and toes in soft mud, where they'd paused for a while. There were five of them – adults and children – and the tallest was around 5 feet 9 inches. It seems then that they were a family. They were almost certainly nomadic people who were hunting deer, bison, rhino and mammoths.

Extraordinarily, as well as these footprints, the area has also provided the largest almost complete mammoth skeleton known, and it's the oldest one ever found in the UK.

Across these 16 miles or so of coast there are over 20,000 fossils found every year. They have included a 500,000-year-old axe head. This is land that was once joined to Europe, when it was a huge, sweeping plain roamed by wild animals and early hunters.

The Deep History Coast is a really exciting place to visit. It's a wonderful place to walk, and somewhere where you really are walking in the footsteps of history.

9. East Dereham

Birthplace of Norfolk's famous architect – George Skipper.

East Dereham or simply Dereham? There have been debates, and letters to the press! It's an issue that can't be resolved here. Either way this Norfolk town, 15 miles west of Norwich, has a long history.

It's believed that it was on a Roman road, indicating that it was of some importance at that time. We know that the town is on land that was the site of the monastery founded by Saint Withburga, who died around AD 743. Her body

East Dereham.
(Courtesy:
Charles Drake.)

was stolen by monks from Ely, and it's said that as a result the well – inevitably known as the holy well – at St Nicholas' Church in Dereham began to flow.

In the eighteenth century there was a determined attempt to cash in on the popularity of spas, by building a bathhouse over the well. The idea was to make Dereham another Buxton, but the building itself was not attractive and caused much dissent. So much so that in 1800 the then vicar, Revd Benjamin Armstrong, sought (and obtained) permission to have it demolished. It's perhaps as well. Although accepted until proved otherwise, the validity of the entire legend is in question. This is largely because the 'definitive' account involves the monks from Ely coming to Dereham by river at night. There is no river between Ely and Dereham.

What we do know for certain is that the town was the birthplace of George Skipper. His name has come up elsewhere in these Norfolk gems because, as an architect, he has left his stamp on Norfolk with buildings that define an era. Perhaps he was destined to create buildings as his father, Robert, was a carpenter and builder in Dereham.

Initially educated in East Dereham and Norwich, George went on to attend Norwich School of Art. He was there for just a year, but in that time, studying art and architecture, he won prizes for excellence in drawing and geometry. After leaving the school he spent some time abroad in the Netherlands, where he studied art. His father was concerned that this was not the route to a secure future and suggested that architecture, or accountancy, would be more fruitful. Acting on the advice, George went to London, becoming articled to John Lee, a well-respected architect with offices in Bedford Row.

By 1876 he was back in Norfolk, working for his father. This exposure to commercial life seems to have rounded his education, as he now gained business experience to add to his architectural knowledge. Within three years he'd put all of it to use and opened his own architectural practice in East Dereham. There are some accounts that he struggled at first, but the facts are that he built up a healthy order book from the outset and was already busy when he won a competition in 1879 to design a hospital in Shepton Mallet, Somerset. It was an important project in itself, but was also the catalyst for George's reputation to spread beyond Norfolk.

It earned him the patronage of William Clark, founder of the footwear business. He would design a model village for Clark in the Somerset village of Street. Other contracts in the area followed, and today George Skipper's buildings in Somerset are seen as an important contribution to the Victorian building boom.

With a more than healthy portfolio back in Norfolk as well, George decided it was time to be based in Norwich. In June 1880 he took premises in Opie Street in the city's centre. By now in partnership with his brother Frederick, and elected as a Fellow of the Royal Society of British Architects, George Skipper's star was in the ascendancy.

So too was north Norfolk's. This was the time of the railways opening up the north Norfolk coast as a holiday destination, as we've seen in other 'gems'. George's skills were in demand there. Aside from hotels such as The Grand, Hotel de Paris and The Cliftonville, he designed the town hall for Cromer and the one in Hunstanton.

Married for the second time and by modern definitions a 'workaholic', he took on commissions for private villas as well in Sheringham and Gorleston.

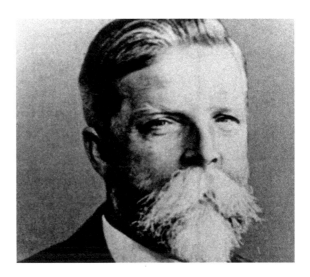

George Skipper.

He also designed new offices for himself. His practice now employed some fifty people and his new place of work was stylish and impressive. Using local materials and his signature style, he built his new offices at No. 7 London Street, Norwich. Now part of the Jarrolds department store, the building still features a relief that George had crafted into the façade. It shows six decorative panels, each depicting an architectural trade. Ostensibly an Arts and Crafts-style reference to trades people, it was actually something else as well. It was a means of saying what went on within the premises. Why? Because regulations stipulated that architects were not allowed to advertise their business on their premises. George Skipper had found a way around that!

Now based in Norwich, he would go on to design buildings there that are of huge importance: the Royal Arcade, Commercial Chambers, and The Savings Bank are all part of the man's legacy. But his outstanding achievement is perhaps the head office of Norwich Union.

The worldwide insurance giant Aviva, as it is known today, had been established in Norwich and the new Norwich Union Life Division wanted an impressive headquarters. They turned to George, who, in a business coup, persuaded them to buy a consignment of marble that had originally been intended for Westminster Cathedral. Some financial problems had halted the project and George obtained a hefty discount on the stone. The results are amazing. 'The Marble Hall', as it's still called, features forty marble columns, worked by Italian craftsmen. It is still the head office of Aviva today.

Opening in 1905, it combined a classical style with the latest innovations for offices. It's a breathtaking interior.

George Skipper's personal life wasn't always straightforward, but he led a busy, creative life and he lived on well into the twentieth century, passing away in 1948 just before his ninety-second birthday.

The lad from East Dereham has left an architectural legacy from Somerset to London, but he made a massive impact on Norfolk, and several of its 'gems'.

10. East Ruston Old Vicarage

These spectacular privately owned gardens are the creation of Alan Gray and Graham Robeson. Established initially in 1973, the gardens cover some 32 acres of what by any standards was a challenging landscape for such a project. Surrounded by the prairie-like arable fields and close to the North Sea, it was, according to the new owners, 'a blank canvass'.

By planting 'shelter belts' of primarily Monterey pine they have in effect created a microclimate, protected from the worst of the weather. It's allowed the planting of a vast range of species, some rare and unusual. The Dutch Garden, the Tree Fern Garden, the Rose Garden, and the Exotic Garden are just some of the almost twenty individual, creatively planted, areas that now cover the entire project.

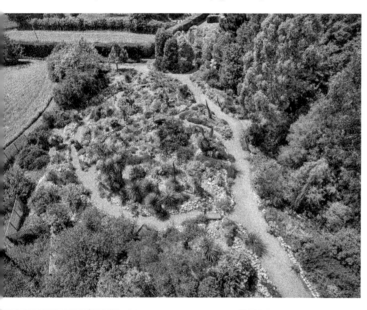

An aerial view of East Ruston Gardens. (Courtesy: East Ruston Gardens.)

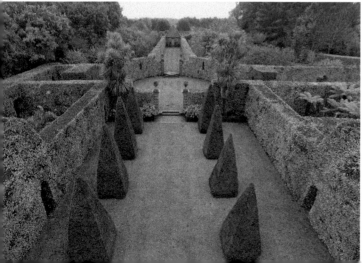

East Ruston Gardens. (Courtesy: East Ruston Gardens.)

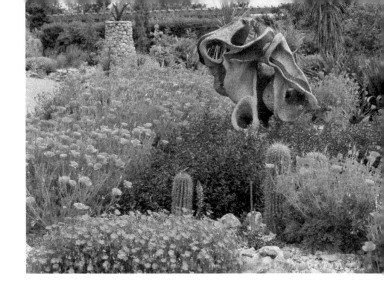

Desert garden with sculpture at East Ruston Gardens. (Courtesy: East Ruston Gardens.)

A mixture of modern, innovative planting with some more traditional designs heightens the overall appeal of this truly amazing place. For added interest, within the planting is a collection of sculptures by local artists.

Each garden has been designed by the two owners, who have said that their mission was to enhance the setting of their home. Open to the public, it is now a source of great delight to masses of visitors every year.

11. Felbrigg Hall

Although still known as Felbrigg Hall, this estate was actually bought from the Felbrigg family by John Wyndham in the fifteenth century. He died in 1475 and subsequent Wyndhams who lived there included Thomas, who was a councillor to Henry VIII, and a second John (1558–1645), who is credited with the building of Felbrigg Hall. Wyndhams would remain there until the death of William Wyndham in 1810. Eventually, Felbrigg was owned by the historian Robert Wyndham Ketton-Cremer, who died unmarried and without heirs in 1969, when the estate passed to the National Trust.

Before looking at Felbrigg today it's impossible not to comment on the events that propelled it to national notoriety in the nineteenth century.

William Frederick Windham – by now the 'Norfolk' spelling of the name had been adopted – was a complex character. A troubled child, he was also a rowdy adolescent, earning the nickname 'Mad Windham' while at school. He inherited the Felbrigg estates when he came of age in 1861. His inheritance included a sizeable income of around £9,000. William was not a prudent man. His spending and behaviour characterised him as what today would be called a 'hellraiser'. By the time he'd married a woman of, at the least, controversial

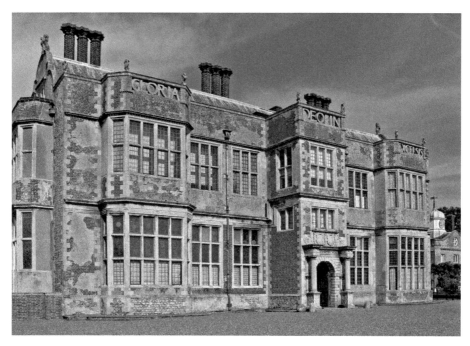

Felbrigg Hall. (Courtesy: www.tournorfolk.co.uk)

character, showered her with jewellery and money and sold-off parts of the estate, the family took legal action to prove that he was not of sound mind.

Some of the leading lawyers of the day were brought to bear on the case, the lurid details of which made for good headlines and much public interest. It's difficult to overstate the sensation that the case caused. On 30 January 1862, the day that Windham's trial ended with him being declared of sound mind, he was physically mobbed. *The Times* commented on the trial as 'unprecedented for its duration, for the scandalous waste of money which it has occasioned, and for the inexpressible filthiness of some of its details'.

Victory, if that's what it was, proved hollow. His legal costs had reached some £20,000 – an astonishing amount at the time – and they ruined him. All but penniless, he moved into the old Norfolk Hotel in Norwich where he lived a life of drinking and excess, frequenting the city's taverns and keeping bad company. When the last of the money ran out, he set up as a coach driver on a run from Norwich to Cromer, which, with supreme irony, would have taken him past the gates of Felbrigg.

His reckless driving became legendary, and almost inevitably the business failed. Soon falling ill he took to his wretched hotel room, where he died in early 1866. An elderly coach man and a few of his hangers-on from the Norwich inns were the only mourners when he was laid to rest in the family vault at Felbrigg.

All of these events are in sharp contrast to the tranquillity of Felbrigg today. The house itself, which is open to visitors, has a feeling of having been occupied by real people and contains an important library, pictures and artefacts. The estate includes acres of woodland, a walled garden, an orangery and orchards.

12. Great Ryburgh

Just a few miles from Fakenham, on the River Wensum, Great Ryburgh has all the hallmarks of a Norfolk village: a traditional inn with an inglenook fireplace, and maltings that have been in the village for 200 years or more. The Church of St Andrew, Great Ryburgh, is one of the 100 or so round tower Norfolk churches, and it dates back to before 1066. And yet, it's Christian worship of an even earlier period that has, in recent times, focussed attention on this village.

In 2016 an excavation by the Museum of London Archaeology, primarily funded by Historic England, revealed something of extraordinary importance. An Anglo-Saxon cemetery would be an exciting find by any standards, but this was different. The waterlogged condition of the soil had preserved not only six plank-lined graves, but also some eighty-one hollowed-out tree-trunk coffins dating from the seventh to ninth centuries AD. It's thought that these are the first coffins of the early Christian period to be found intact in the UK.

There was evidence too of a timber-built structure that's thought to be a chapel, or indeed a church. It seems this was a very early Christian settlement and its discovery is a rare and hugely important insight into how people of the time lived and died.

The dig had been initiated prior to some development work for a lake, with the objectives of conservation and fishing. While pursuing these modern goals, the archaeological team were allowed in first and discovered something of the ancient world. The preservation of the graves and skeletons they found was due to a geological oddity of Norfolk's soil. The mixture of acidic sand and alkaline water had created the ideal conditions for the relics to have survived for so long.

The county, and this small village, had kept their secret for centuries and can now share important knowledge with the world.

13. Great Yarmouth

Great Yarmouth, older even than Norwich, is a town of many facets. Once an important fishing port, a seaside resort since the 1760s, and tied to the energy industries in one form or another since the discovery of North Sea oil in the 1960s, it's had a rich and complicated history.

It's a history that encompasses King John granting it a charter in 1208, a grammar school being founded there in 1551, and it being featured in Daniel Defoe's eighteenth-century travel journals.

Regent Road, Great Yarmouth. (Courtesy: Romazur.)

Charles Dickens used Great Yarmouth as a location for *David Copperfield* in the nineteenth century and in the twentieth century the town became the first to suffer an aerial bombardment when it was attacked by Zeppelin L3 in January 1915.

Great Yarmouth has an important maritime history, having been the Royal Navy's supply base for the French Revolutionary Wars in 1797, and the anchoring point for the fleet in the Napoleonic Wars.

Its role as a fishing port spanned centuries, with an industry built on the herring catch, but it was in decline by the mid-1900s and has now all but disappeared.

What the sea offered next was oil. North Sea oil was a rejuvenating factor for 1960s Great Yarmouth. Aside from the rigs themselves, the town developed a network of industries and services to supply the oil business. Those support services have adapted to provide for today's natural gas rigs. Today, as the energy industry changes again, the town looks out on the generators of the wind farm on Scroby Sands.

But for all its military and commercial history, for generations of people from Norfolk and further afield, Great Yarmouth is a holiday resort. A place to go for fun.

The beach is an impressive sweep of golden sands and is bordered by a seafront promenade known as 'the Golden Mile'. It's a place of hotels, restaurants and cafés; it's where the Britannia Pier juts out into the sea, and where you'll find the Pleasure Beach.

Further in to the town is the market. For six days a week the place is alive with stalls selling fruit and vegetables, books, ice cream, tea, and the legendary Great Yarmouth chips.

The 'Golden Mile', Great Yarmouth. (Courtesy: Daniel Tink.)

Entertainment has long been a feature of Great Yarmouth's summer seasons, and many famous names have played its theatres, and continue to do so today. For those looking for more sedate attractions, the town has some outstanding museums, including the Time & Tide and the Elizabethan House.

The Venetian Waterways are another feature of the town. Located on the seafront, they are man-made boating courses. Developed on reclaimed land, resulting from sea wall construction in the 1920s, the waterways were built in 1927 and 1928 as part of the winter relief work for the unemployed.

Some say that Great Yarmouth has a 'kiss me quick' seaside appeal in comparison to some of Norfolk's gems. It does have a jauntiness about it, but it's loved for it. Generations of Norfolk natives have gone to Great Yarmouth for holidays and days out, and treasure memories of its beach, rides, chips and ice cream. It's very much part of the fabric of the county, and always worth a visit.

Chapter 2

14. Grimes Graves

Around 4.5 miles north-east of Brandon, in the midst of Norfolk's Breckland, there is a site of enormous historic interest. Named 'Grim's Graves' by Anglo-Saxon inhabitants, and known now as Grimes Graves, this is a genuine Neolithic flint mine. These are workings that were actively in use, being mined, over 5,000 years ago. It is an astonishing place.

Miners worked here as early as around 3000 BC. Over 400 shafts were dug down into the chalk across an area of over 90 acres (37 ha) to obtain one vital resource: flint. It was flint that was used to make tools and weapons. As a material it was central to Neolithic life, and it's fascinating to consider how, in some ways so primitively and yet in others so surprisingly sophisticatedly, these great mines operated.

Using axes that were little more than the antlers from red deer, the miners chipped at the chalk, prising the flint away by hand, working in harsh and dangerous conditions. And yet they built an entire infrastructure to service the mines; mines that were established by building wooden platforms, with ladders descending into the shafts, from where a network of galleries spread out to the diggings. Once the 'season' for good mining was over the galleries were filled for stability.

All of this was all but lost to history until, in 1870, one of the shafts was excavated, and it became clear that these were indeed 5,000-year-old flint mines. Further research has shown just how complex the workings were, and what a sizeable industry this was. It's estimated for instance that if just two shafts were operational at any one time, there would have been a need for approximately 120 deer to be bred nearby, simply to generate enough antlers to be used as tools. The skin, meat, and other by products would all have been put to use by the mining community.

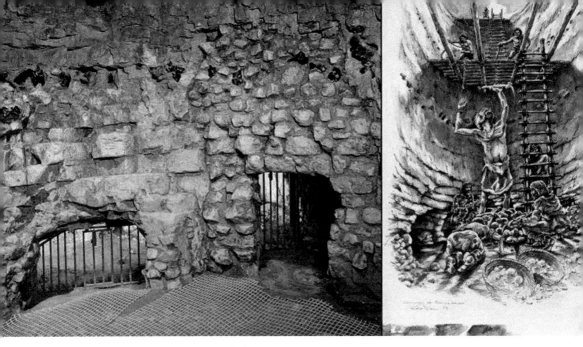

Grimes Graves. (Courtesy: English Heritage.)

Grimes Graves. (Courtesy:
Dr Miles Russell.)

There are other flint mines in the UK, but Grimes Graves is important. It's also the only one open to the public. Now in the care of English Heritage, the site features an exhibition area and, most excitingly of all, allows access by a 9-metre ladder to one of the shafts. It's like climbing down into the history of Norfolk itself.

15. Halvergate

Halvergate Marshes may not, in truth, present the most picturesque view in Norfolk. But they deserve a place in this list of Norfolk's gems because of the events in the 1980s that said much for the Norfolk character, and had international consequences.

Part of the old, traditional Broadland landscape, these marshes had been frozen in time for years; traditional agriculture had coexisted with diverse wildlife and vegetation in a landscape drained by pumps manned by 'marshmen'. Little had changed in centuries.

In 1980 the prosaically named Lower Bure, Halvergate Fleet & Acle Marshes Internal Drainage Board became the catalyst for what it saw as necessary development. The 'old ways' were becoming less and less profitable. As a result, a shift away from grazing cattle towards arable farming had begun.

Now, the Lower Bure, Halvergate Fleet & Acle Marshes Internal Drainage Board wanted to convert Halvergate Marshes to arable farming. To start the process they submitted the necessary forms to the Ministry of Agriculture asking for a grant. The grant was to cover new pumps, drainage work and road building. It would affect around 5,000 acres. Work of this type, and the processes involved, was not unprecedented. What was new, however, was a Ministry of Agriculture policy to advise local authorities of intentions and applications regarding land drainage. The new policy therefore meant that the Drainage Board had to contact and consult with the then new Broads Authority. This looked very much like a first and demanding test for the much desired 'cohesive and central management organisation' for the Broads. It was a delicate situation. This was commerce affecting the Broads, but it wasn't the new tourist industry sector – it was ancient agriculture. Farmers' livelihoods were in question.

The Broads Authority objected to the request on the grounds of conservation. This meant that the grant was not forthcoming. Negotiations began. It was complicated. For a start, the new Broads Authority had farmers among its members and diplomacy would be needed as the National Farmers Union was staunchly behind the Drainage Board. Added to that was the financial problem that could develop: farmers having been refused permission to convert to arable would want compensation.

There were protracted, sometimes acrimonious, discussions. Agreements were reached, only to fall apart. The Countryside Commission was called in and they,

increasingly exasperated, called for a public inquiry. This was ironic. So many times in recent years Norfolk had, typically, gone against the grain, insisting that management of the Broads should be from a local perspective, as opposed to national government policy. Now, the government were insistent that the solution be found locally.

The solution couldn't be found. And then, unexpectedly, and without consulting any of the admittedly stalemated parties, the government implemented Section 48 of the Wildlife & Countryside Act. It meant that they agreed to finance some new pumps, but they drew a line as to the rest of the grant. This appeared to be a brave move initially. It was the first time that grant aid had not been forthcoming because conservation had been deemed to take precedence over agriculture. It was a step, but it hadn't gone far enough. It felt like unfinished business.

Time passed and farmers still pressed for land to be converted to arable use. The financial implications for the Broads Authority, if the conversions were halted and compensation was sought, hung in the air.

There were more negotiations, and now it got physical. There were demonstrations by Friends of the Earth, who stood in the way of tractors and equipment, and grabbed national media exposure for doing so. A Mr Wright who farmed there had, through the machinations of the legal discussions, found himself, in effect, permitted to plough. The demonstration in front of his equipment daunted him and he stopped, saying that he would settle for the Authority's previous offer, which he had declined. When the Broads Authority would go no further than that original offer, Mr Wright prepared again to plough. And the Friends of the Earth prepared to stop him again.

The legal machinations continued throughout 1984 and into 1985, when it was the Countryside Commission who found a way through. The plan involved some careful interpretation of legal requirements. There was a bigger picture to consider as these were the days of the controversial Common Agricultural Policy, making this an international issue. The point was that those who opposed the farmers in their attempts to turn traditional grazing land into arable farms saw the shift as not only a conservation issue, but one driven by the chance to make a profit from selling grain that might never find its way to market. Many were the stories of vast quantities of crop doing nothing other than contribute to what was called the 'EEC grain mountain'.

The solution came in the form of the highly innovative and historically important Broads Grazing Marshes Conservation Scheme. In an unprecedented move, it was made possible to pay farmers compensation of £50 per acre if they allowed the land to continue to be used for grazing. Such was the complexity of the plan that it involved the government in setting the European precedent for the establishment of Environmentally Sensitive Areas.

In short, when the farmers accepted compensation and the negotiations and legalities were resolved, in 1987 Halvergate Marshes became the UK's first 'Environmentally Sensitive Area', and set the prototype nationally.

So then, although not the most picturesque view in Broadland, it's worth noting that Halvergate has a special place in Norfolk's, and the country's, history.

16. Happisburgh (and the Lighthouse)

There are others (such as Wymondham) but Happisburgh is probably Norfolk's most famous mispronunciation. It's said as 'Haysborough', or as some pronunciation guides explain it, 'Hazebruh', which is not, admittedly, obvious from its spelling.

On the north-east coast of Norfolk, Happisburgh has a long story to tell. There are many Norfolk villages, all of them gems of history, with their names recorded in the Domesday Book and often traceable to before that. Happisburgh, though, sets an altogether different standard in longevity. Flint tools found on Happisburgh's foreshore are among the evidence for this village to be the site of the first known human settlement in northern Europe. People lived here 800,000 years ago.

In more recent times, it's somewhere the sea has taken its toll with years of erosion. It's a measurable effect. The parish of Happisburgh shrank by more than 0.2 square kilometres during the twentieth century, entirely because of the coastal erosion of its beaches and cliffs.

Being so close to the power of the sea has meant that Happisburgh has long had a lighthouse. Naturally enough, Happisburgh's lighthouse is highly visible; a beacon and a welcome point of reference for those on the sea. It's also a symbol, a shining example of determination and public spiritedness. The building itself dates back to 1790. In its original form the lighthouse was candle powered, and operated as one of a pair – known as 'High Lighthouse' and 'Low Lighthouse'. Low Lighthouse was taken out of service and demolished in 1883 because, even

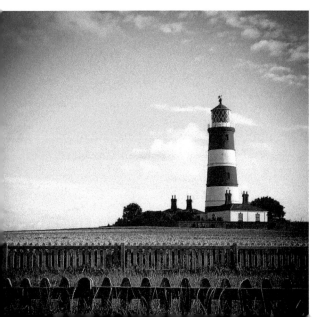

Happisburgh. (Courtesy: Roots and Toots Blog, www.rootsandtoots.com)

then, coastal erosion was a concern and there were fears that it would be lost. Its lantern was saved and recycled, being put to work in Southwold Lighthouse. High Lighthouse remained, and is now the oldest working lighthouse in East Anglia.

The reason for this unique status is that it was one of five lighthouses that Trinity House declared 'redundant' in 1987. With decommissioning scheduled for 1988, the villagers mounted a defence, and their petition resulted in the date being postponed.

Legal complications ensued in that the Merchant Shipping Act of 1894 meant that Trinity House could only dispose of a lighthouse to an established Lighthouse Authority. Creating such an authority required the promoting of a private bill through Parliament. Unbowed, local folk pressed on, launching a campaign to raise the funds necessary to do just that.

It was successful. On 25 April 1990 royal assent was given to the bill, creating the Happisburgh Lighthouse Trust, and establishing it as a 'Local Light Authority'. The oldest lighthouse in East Anglia now became the only independently operated one in the UK.

Two months later, on 20 June 1990, Her Majesty Queen Elizabeth, the Queen Mother, visited Happisburgh lighthouse. Soon after that it received another high profile, although less royal, guest.

Challenge Anneka was a very popular TV show in the early 1990s. A vehicle for Anneka Rice, and a development of her role in *Treasure Hunt*, it set projects for the presenter and volunteers to be completed against the clock. The episode on 30 August 1990 challenged Anneka to repaint Happisburgh lighthouse. In thirty-three hours a team of volunteers completed the job.

There would be a twist in the tale. By 1997 the paint was beginning to flake and the TV show was criticised in the media. It was the Happisburgh Lighthouse Trust who pointed out that they remained forever grateful to *Challenge Anneka* and it was in fact a later repaint, in 1994, that was causing the flaking.

Today, the red-and-white striped tower is as visible on shore as its beam is at sea.

17. Hethel (and Lotus)

Norfolk is the home, and in some cases birthplace, of many famous brands – Aviva, Barclays, Colman's and many more all have their origins here. Although not 'born' in Norfolk, Lotus Cars are an integral part of the county's commerce and a vital part of the country's automotive history.

Colin Chapman was a visionary engineer with a passion for cars. As early as 1948, having graduated as an engineer, he was modifying an elderly Austin Seven to compete in local trials. The crucial link to Norfolk began in 1966 when Lotus moved into a factory on the site of the old RAF base at Hethel, near Wymondham.

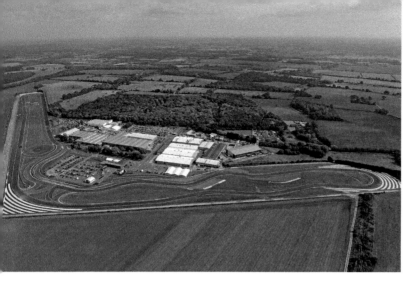

The Lotus Track, Hethel. (Courtesy: Group Lotus plc.)

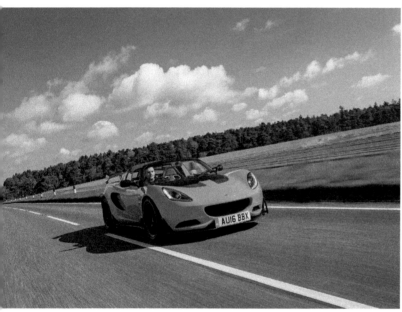

Lotus Elise. (Courtesy: Group Lotus plc.)

It's from there, starting in the 1960s, that the litany of Lotus models took the world by storm. The Elite of the 1950s was followed by the legendary Elan, and later the Europa with its typically lightweight body, backbone chassis and mid-mounted Renault engine. The 1970s would bring the Eclat, and the Esprit, which would not only prove popular and long lived but also featured Lotus' own 900 series engine.

In a development that switched design and production from a 'supercar' format, Lotus returned to thorough-bred sports cars with the launch of the Elise in 1996. It met with universal acclaim. Today it sits alongside models including the Exige and Evora, each of them representing the handmade craftsmanship, world-class engineering, technology and performance that have been the hallmarks of the brand since its inception.

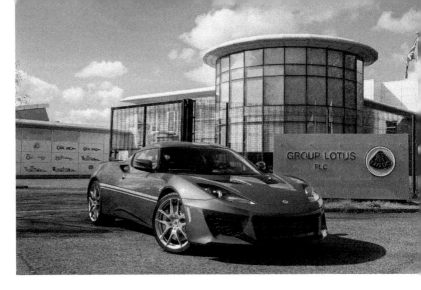

Lotus Evora.
(Courtesy: Group
Lotus plc.)

In 2002 the company was awarded the Queen's Award for Enterprise for its contribution to international trade, acknowledging the export of cars across the world. And world fame has of course been heightened by the legend of Lotus on the Formula One track. Seven constructor and six driver awards total thirteen F1 World Championships. Many of those achievements, spanning 1968–78, came out of Lotus in Norfolk.

This very special piece of motoring history, and current commerce, is an integral part of the county.

18. Heydon

Heydon is, in one way, like some people say of Norfolk itself: you can't pass through it – you have to be going there. It's true, because Heydon has no through road.

And yet, for somewhere so secluded, Heydon is really quite famous. It's so lovely and full of character that it's often appeared as the location for films and TV shows – including the Anglia Television soap opera *Weaver's Green*. Films shot in the village, at least in part, include: *The Go Between*, *Riders*, *Hitler's Britain*, *Vanity Fair*, *The Woman in White*, *The Moonstone*, *The Peppermint Pig*, and *A Cock and Bull Story*.

In the centre of the village is the well. On the face of it this well is typical of its type and certainly not unusual in that it was built, as were so many public constructions, to commemorate Queen Victoria's Golden Jubilee in 1887. What makes Heydon's 1887 decidedly unusual is that it was the last new building in the village. There has been no new building here since.

Heydon is in fact one of the handful of villages in England that are still privately owned. It is the property of the Bulwer Long family, who also own Heydon Hall.

Heydon.
(Courtesy: John
Fielding.)

Their family tree includes the writer Edward Bulwer Lytton. A literary giant of
the nineteenth century, he's not read much nowadays, although, just as you think
you might not know Heydon but you've seen it in films, you may not know the
works of Edward Bulwer Lytton but you may well have used phrases that he
was the first to coin. For instance, 'the great unwashed' and 'the pen is mightier
than the sword' come from him. And one of his opening lines is truly immortal:
'it was a dark and stormy night'!

The early 1970s saw Heydon make the news in two ways. Firstly, the
splendid late medieval Church of St Peter and St Paul contains some notable wall
paintings, but they were only rediscovered in 1970. And in 1971 Heydon became
Norfolk's first conservation area.

'Picture postcard' or 'chocolate box' would be easy descriptions to use for
Heydon. But they would be unfairly twee. It's a village of real tranquillity, with
its pub, church and tea shop facing on to the village green, complete with its
newest building – the nineteenth-century well! And yet, for all its being frozen in
time, quietly nestling in the Norfolk countryside, around 5 miles from Reepham,
it's a real village. But so charming. It's no surprise that it's won 'Best Kept
Village' – twice!

19. Hingham

Hingham is around 15 miles from Norwich on the Watton Road. A market town
of just under a 1,000 households, it has a similar story to Holt in that older
buildings in the town were destroyed by a fire. In Hingham the townsfolk, in
particular the gentry, built new houses, resulting in the truly handsome Georgian
buildings that look out on to the village green and market place.

It seems that the people of Holt were not only fashionable in their architecture, they were also stylish in their dress. The combination of well-turned-out citizens living in impressive houses led to Hingham being known as 'Little London'. But it's links to further afield than London that make Hingham historically fascinating.

To begin with the early history, we know that Hingham had been established by AD 925. It was at that point 'owned' by King Athelstan. His name may have faded from history, but his grandson's hasn't. Athelstan was grandfather to no less a personage than King Alfred – the one who burned the cakes.

Alfred achieved more, though, than spoiling an early bake-off. He negotiated a peace with the Vikings who were constantly making raids on England. To stop the fighting Alfred arranged for lands to be divided, allowing for settlements and peace. (The Viking king with whom he struck peace was Guthrun, whose name has been passed down and exists in Norfolk today as, it's believed, Goodrum.)

And so we come to later history, and some more Hingham connections. Hingham's town sign holds a clue, in that it depicts people setting sail. Between 1633 and 1643 a number of people from Hingham emigrated to the New World – America. They were Puritans and effectively led by Robert Peck (who had been Hingham's vicar) and his close friend Peter Hobart.

We can only imagine what the journey must have been like. These Norfolk citizens would have been at sea for a long time, and would travel further than they could ever have imagined possible. When they arrived, they settled in what was then still the colony of Massachusetts and founded a town – Hingham.

It's highly likely that the catalyst for Robert Peck wanting to go was his having been admonished by the Church for his strictly Puritan beliefs and practices. Such was his immersion in the Puritan movement that his daughter had married John Rogers, a well-known and high-profile Puritan, who was vicar at Hingham for a time but later found national fame for his impassioned preaching. So fiery were his speeches that he became known as 'Roaring John Rogers'!

Whatever the reason for his emigration, Robert Peck was influential and charismatic. He took with him over 200 people from Hingham and the effect on the town was noticeable. The town petitioned Parliament for help because, they said, the town had been 'devastated' by this exodus.

If they'd made an impact by leaving Hingham, Norfolk, UK, at least two of them would make a mark having settled in Hingham, Massachusetts, USA. Edward Gilman was an ancestor to Nicholas Gilman, who would be a signatory of the US Constitution. And Samuel Lincoln would have a descendant called Abraham Lincoln, who, of course, would become president of the USA.

Understandably, Hingham has remembered these names. St Andrew's Church contains a memorial to the Gilman family – two of whom would become mayors of Norwich – and there's a bust of Abraham Lincoln too.

Those seventeenth-century emigrants and founders of an American town could never have foreseen how the two countries, and Hingham, would be tied together again in a time of war. A war the like of which they also could not have imagined.

St Andrew's is a fine church, built in the fourteenth century, long before America was a nation. On the edge of its grounds is a memorial to the men of the 452nd Bomb Group. American men who came to the 'old country' when it needed them. Men who came to the very place that their forefathers had left.

They flew 250 missions from near here. It was brutal. They lost 110 Flying Fortresses before flying their last wartime mission in April 1945. Returning home that August, they were decommissioned the same month in South Dakota. In Hingham, they are not forgotten.

Since those wartime years of the 1940s Hingham has blossomed into the fine little Norfolk town it is today. Traditions still carry on, including the annual fair that takes place on the triangular greens known as Fairlands. There is business here, with local companies operating from a small industrial estate, and a number of shops in the town centre. Hingham has its own school and, even though some residents commute into Norwich for work, it's a real community.

If you want to see a real Norfolk market town of charm and style with a fascinating history, look no further than Hingham.

20. Holkham

If there's one name that characterises the Agricultural Revolution it's Coke – 'Farmer' Coke of Norfolk.

Thomas William Coke inherited Holkham Hall in 1776 and he immediately set about a forty-year task of improving agricultural methods. His innovations in seed drilling, crop rotation, and sheep and cattle breeding became famous nationally and internationally, making a real contribution to the great agricultural developments of the late eighteenth century.

Today, while the significance of its place in history must never be overlooked, it's the sheer majesty of the beach and coastline at Holkham that makes it so special. If Norfolk is famous for big skies and wide beaches, it's Holkham that defines them.

Holkham Beach is probably one of the most natural, unspoiled, stretches of seashore in the country; 4 miles of almost-white sand roll out between the sea and pine woods. Managed by Natural England in partnership with the Holkham Estate, it's one of the largest national nature reserves in the country, and the estate is visited by over half a million people a year.

The beach has won many awards, including a travel writers' 'Best Beach in the UK'.

Holkham Hall.
(Courtesy: Holkham
Estate.)

Holkham. (Courtesy:
Holkham Estate.)

Dog friendly (it won a Kennel Club award too!), it's a place to walk away the cares of daily life.

Aside from awards Holkham Beach has had several brushes with fame. In 2013 a ban on naturists using a section of the beach was withdrawn after a considerable outcry.

The vastness of the beach makes it immensely photogenic. In 1998 it featured as the spectacular backdrop to Gwyneth Paltrow's closing scenes for the film *Shakespeare in Love*. The following year All Saints filmed the video for their hit 'Pure Shores' there. It's well known that the royal family are fans of Holkham and when they released, hitherto unseen, pictures from their private albums to mark the queen's Diamond Jubilee, the collection included photographs of Prince Charles and Princess Anne as children playing on the beach.

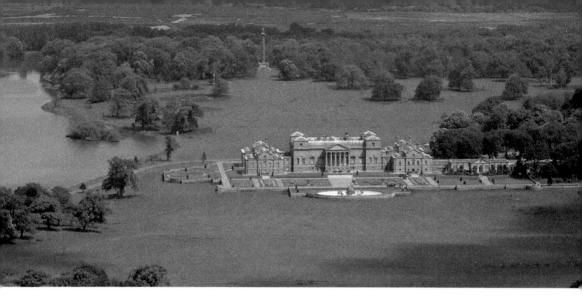

Holkham Hall. (Courtesy: Holkham Estate.)

Although there is a nearby pub and plenty of space to park cars, the beach itself has no facilities. It is a truly natural, wonderfully tranquil, expanse. To walk Holkham Beach is to experience the full majesty of the Norfolk coast.

21. Holt

Holt is a very handsome town. It's largely Georgian buildings exude an eighteenth- and early nineteenth-century elegance that perfectly suits its pace of life and stylish atmosphere. And yet, the town predates the eighteenth century by a long way. Its name is known to be of Anglo-Saxon origin, suggesting a very early settlement there, and we know that Holt is mentioned in the Domesday Book of 1086. The reason the town looks as if it belongs to a time long after its origins can be identified in one word: fire.

In the heart of Holt is Shirehall Plain. On 1 May 1708, the plain was crammed with people. It was the centre of the town and full of traders, townsfolk and farmers from nearby, all jostling at busy market stalls. Suddenly, in the middle of it all, fire broke out. It spread terrifyingly quickly. The flames ignited the town's wooden buildings, which were burned to the ground. Even the church was ruined. It was catastrophic and breathtakingly rapid. It's said that the butchers didn't even have time to save the meat from their market stalls. In just three hours Holt was destroyed.

It took decades, but the Market Place, High Street and town centre were rebuilt, which is why the buildings are predominantly Georgian and why Holt looks the way it does today. Away from the centre of town the side streets took longer to replace and rebuild and it's noticeable that they are of the later,

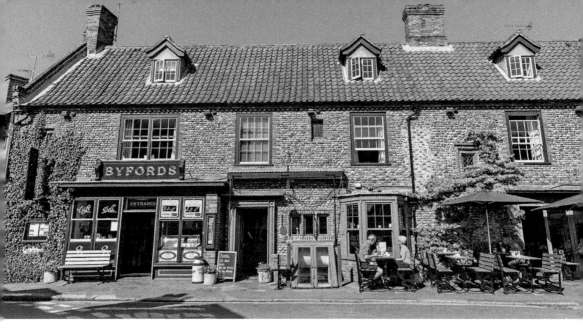

Byfords in Holt. (Courtesy: Byfords, Holt.)

Victorian period. And many of those Victorian dwellings are now the shops and cafés that are so popular in modern Holt.

Very much part of modern Holt is Byfords, the hugely popular café and delicatessen. It's in the town centre, in what's possibly the oldest building in Holt. Ironically the house survived not only the great fire of 1708 but another one in 1906!

At the end of the High Street there are two objects of interest. Surrounded by the modern life of busy, stylish Holt they both have stories to tell.

'The Obelisk' is in fact one of a pair gateposts from Melton Constable Park. For reasons lost in history, in 1757 one of the pineapple-topped posts was given to the town of Dereham, the other to Holt. Each gatepost had the distances to various places from Holt and Dereham carved into the stone. At the outbreak of the Second World War there were fears that, should there be an invasion, this geographic information would be of use to the enemy, allowing them to orientate themselves in the locality. The folk of Dereham decided that the best course of action was to dump their post down a well. It's still there. In Holt they had a different plan. They kept their gatepost, or obelisk, and whitewashed it. It's still there too!

Near to 'the Obelisk' is 'Blind Sam'. Blind Sam is a lantern, made to celebrate Queen Victoria's Jubilee in 1887. Originally it stood in the Market Place and had two jobs: it gave light to the square and provided drinking water from two fountains at its foot. The problem was that the light was powered by the town's own gas supply. At the time this was so sporadic and famously unreliable that the light could never be depended upon – so came the nickname 'Blind Sam'. It was moved in 1921 to make way for the war memorial.

Holt is a thriving place, hosting an annual festival each July featuring an eclectic mix of international music, drama, comedy, visual art, street theatre, workshops and cinema. At Christmas, Holt's festive lights are acknowledged as some of the best in Norfolk.

Just outside the town is Holt Country Park. It's been a racecourse and farmland but is now tranquil woodland and hugely popular as a place to walk. It's free – with just small charge for parking – and full of flora and fauna. It's achieved a Green Flag Award every year since 2005, and is well worth a visit.

22. Horsey Beach

By far and away the main reason people visit this Norfolk beach is to see the seals. It is a wild and wonderful piece of the Norfolk coastline in itself, and well worth a walk, but it's the seals in winter that add magic to Horsey Beach.

It is an unspoilt place, and with that blessing comes some warnings. It can be cold on Norfolk's dunes in winter, so you need to be properly dressed and prepared for that. The tracks to the viewing points are not at their easiest in winter either. In truth it's difficult for those with limited mobility or people in wheelchairs. And, if you go in winter, when it's best to see the seals, you need to remember that the days are short; it gets dark early, and Horsey is not a place of street lamps. All of that said, parking the car at Horsey Gap and walking the mile or so to a viewing point brings rich rewards. To look down on to the beach and see these creatures is a rare and wonderful thing.

Grey seals come ashore to breed and Horsey is one of their breeding grounds, called a 'rookery' or 'haul out'. The females arrive first, followed by the males, who compete for the best places. These great mammals wean their pups for three weeks or so before leaving them. The young ones survive on fat they've built

Seals at Horsey. (Courtesy: the Norfolk Coast Partnership.)

up from their mothers until, hungry, they make their way to the sea where they learn to feed themselves.

On Horsey Beach you'll see the whole process stretched out before you. The parents caring, then moving on, in their inimitable and strange motion. The pups, some possibly born that day and still bloodied by birth; some moulting their first coat for the distinctive mottled one, by now waterproof.

On some days the sheer number of seals on Horsey Beach is difficult to take in. It's a panorama of nature in its real habitat. Life begins and ends here. While over half of the pups born here won't survive their first year, their mothers mate again as soon as a pup is weaned, returning to the same place to give birth again the following season. Most of the births are between November and the middle of December, which is why you'll find most visitors at Horsey around the Christmas and New Year breaks.

Horsey is so important a place in the world of grey seals that there is an organisation – Friends of Horsey Seals – dedicated to their protection. Set up in 2012, Friends took over as wardens at Horsey from Natural England when government funding priorities changed. Their objectives are clear:

- To increase knowledge, understanding and enjoyment of grey seals.
- To work with land owners, agencies and the local community to increase protection of the grey seal colony.
- To operate and manage an effective seal warden scheme.

They are always open to new members, and helpful with information and guidance.

The way to Horsey Beach can sometimes be demanding. There are steps and paths and weather to contend with. But, for a sheer spectacle of nature – a glimpse into wildlife like no other – this is an exhilarating experience.

23. Hunstanton

'Sunny Hunny' they call it. The resort on the Wash, famous equally for the amount of sun it gets on summer days and for its striking sunsets on summer nights.

It's been a popular holiday destination since the 1860s, and it has all the charm of a Victorian seaside town. It was known at first as New Hunstanton, to establish it as a different place from its much older neighbour, the village that is now known as Old Hunstanton. The original village may have taken its name from the River Hun or, possibly, from a local stone known as 'honeystone'. It's not certain. What there is no doubt about is that 'Old' Hunstanton is indeed a very old village, with

The cliffs at
Hunstanton.
(Courtesy: M. J. Wase
Photography.)

origins that can be traced back to prehistoric times, and 'New' Hunstanton is a relatively new town, having been built in the nineteenth century.

Henry Styleman Le Strange was born in 1815. He was a man of some vision and commercial acumen. In 1846 he conceived the idea of developing a seaside and bathing resort to the south of the original Hunstanton. So certain was he that his scheme would come to fruition that he had Old Hunstanton's already ancient village cross moved to his new site. Two years later, in 1848, the Royal Hotel – 'New' Hunstanton's first building – had been erected.

Le Strange was passionate about his plan for a resort, and in keeping with the spirit of the times he saw the potential for the railways. Convincing a number of investors to fund it, he was instrumental in the building of a railway line from King's Lynn to Hunstanton, increasing its accessibility to holidaymakers. In fact the Lynn & Hunstanton Railway proved to be very successful, even by the standards of the railway-mad Victorians. It became one of the most profitable railways in England.

Meanwhile, back on site, by 1850 Le Strange had hired a land agent to carry out a full survey of the area he intended to develop. A keen, albeit amateur, architect and artist Le Strange set about producing designs for the new town, including shops and a church, all in the then fashionable Victorian Gothic style. The architect William Butterfield, who had designed the Royal Hotel for Hunstanton, was a willing partner. The result of all this was the truly Victorian seaside town of Hunstanton, much of which exists today as a wonderful example of the period.

Sadly, Le Strange would not see the full fruition of his dreams. In 1862, by which time his town and his railway were both underway, he died. He was just forty-seven. His son, Hamon, would carry on the work.

Today Hunstanton is the popular family holiday destination that LeStrange had envisaged. It's blessed with beautiful Norfolk beaches, sea views from the cliffs, and a busy calendar of events. The town centre is a bustling place with cafés and restaurants, and of course places to buy ice cream and seaside rock. There's plenty of holiday accommodation in the area too, including self-catering and hotels. One of them is called the Le Strange Arms.

Hunstanton Priory.
(Courtesy: www.
tournorfolk.co.uk)

24. The Norfolk Coast Path

Originally this 45-mile-long path ran from Hunstanton to Cromer. In 2014 the first part of the England Coast Path to be opened in Norfolk effectively extended the Norfolk Coast Path by some miles, taking it to Sea Palling.

A large part of the trail is within the North Norfolk Coast AONB (Area of Outstanding Natural Beauty). Two other famous and well-trodden routes link with the path: it joins the Peddars Way at Holme-next-the-Sea and Weaver's Way at Cromer.

First opened in 1986, it's become a hugely popular route for both serious walkers and holiday or leisure strollers. The towns and villages that walkers pass through are a joy, and variety, in themselves. Busy resorts such as Cromer and Hunstanton contrast beautifully with the salt marshes near Brancaster and the legendary beaches at Holkham.

One of the greatest things about the Norfolk Coast Path is that it affords such a wonderful opportunity to get to know Norfolk. However much of the route you take on in one go, there are so many aspects of the county to see. It's ideal birdwatching territory and there's plenty of wildlife to see. Cliffs and dunes, beaches and harbours make up the varied and picturesque coastline. There are nature reserves at Holme Dunes and Scolt Head, and historic houses at Holkham and Felbrigg. And, if the sights appeal, but a long walk doesn't, there are regular local bus services in the immediate area.

It's a constantly evolving route and there's plenty of information available from local sources and online. The walks are safe, but walkers should think about appropriate footwear. As to sustenance, there are plenty of places to eat and drink along the way. How seriously or not you tackle it, the Norfolk Coast Path is high on any 'must do' lists in Norfolk.

The Norfolk Coast Path. (Courtesy: the Norfolk Coast Partnership.)

25. The North Norfolk Railway

Also known as 'the Poppy Line', the North Norfolk Railway runs between Sheringham and Holt, passing through classic north Norfolk scenery on its route. The line was originally part of the long-gone Midland & Great Northern Joint Railway, which has its own place in railway history as it was owned jointly, as its name suggests, by the Midland Railway and the Great Northern Railway. It subsequently became part of the London North Eastern Railway when the railway companies were 'grouped' in 1926, and carried on until nationalisation in 1948.

Once one of the longest lines in the UK, the M&GN is now remembered by the North Norfolk Railway, which, as a heritage railway, operates this section of the old company's route. North Norfolk Raliway plc was launched in 1965 and work on restoring the line began in earnest in June 1967. By 2006 the enterprise had won the 'Independent Railway of the Year' award.

The 8 kilometres of line runs from Sheringham to Weybourne, where the company has its main restoration facility, to Kelling Heath and on to Holt. At that end of the line Heritage Lottery Funding has provided carriage storage sheds.

Run almost entirely by volunteers, the railway is now an important tourist attraction. Using vintage steam and diesel locomotives, and a variety of rolling

Black Prince – the North Norfolk Railway. (Courtesy: North Norfolk Railway.)

stock, the railway runs regular services and special events including a Steam Gala, a Diesel Gala, the much-loved Santa Special and an annual beer festival.

In operational terms the line is in fact now reconnected to the national rail network at Sheringham.

It's the experience of riding in a restored carriage behind a period locomotive that makes the journey special and so popular. Halting at the wonderfully preserved stations, visiting the attractions and exhibits, and the irresistible walk up the platform to inspect the engine, are all part of the charm. It's a glimpse into the sights, sounds, and smells of a bygone era.

There's also an interesting link to another gem of Norfolk. The locomotive superintendent of the old M&GN, who served the railway for over forty years, was one William Marriott. He figures not only in exhibits on the North Norfolk Railway but is also remembered in Marriott's Way, the popular footpath that follows the trackbed of the original railway's Norwich line.

26. The Norfolk Broads

It's impossible not to include the Broads in a book of Norfolk gems, and almost impossible to tell their history, and paint a picture of them today, in just one chapter.

It's a long history. Paleolithic tribes made a life for themselves in the marshy soil of Norfolk. Copper was worked into tools and utensils here during a sociological shift that developed into the Bronze Age. When the Romans occupied Britain, the sea levels around Norfolk had been falling. Swamps dried out, creating fertile

land. The soil contained large amounts of peat, and the Romans knew how to use that as a fuel, and how to extract it. A vast supply of it, immediately accessible, was too good to resist. They began to dig it out. And then they left.

Vikings arrived next. They were instrumental in sowing the first seeds of Norfolk's agricultural heritage. Despite their reputation, it was a time of peace.

Then it was 1066. When the Normans took hold of Britain, Norfolk prospered. Sheep farming, salt production and a new leather industry meant more people, all of whom needed shelter and warmth. By the twelfth century, having plundered and burned most of the available wood, they turned their attention to peat.

For 200 years or more peat digging was big business. The monks of St Benet's Abbey acquired huge rights to peat cutting. It's estimated that the monastery used 200,000 bales of peat a year itself, and there was also a healthy trade in selling the fuel to Norwich and Great Yarmouth.

Millions of cubic feet of peat were dug out of Norfolk. As the holes got bigger, the sea levels got higher. Water rushed into the diggings. As the fourteenth century dawned, it became impossible to continue cutting peat. The great empty pits had become flooded. Centuries would pass before the lost and voracious peat-cutting industry was identified as their cause, but the Norfolk landscape now had the Broads.

Their man-made origins were sliding from memory. They may have been fished, and doubtless their waters were used for agricultural purposes, but this was their quiet time. It was as if the Broads were sleeping.

Norfolk, though, was becoming hugely important in the nation's economy. Agriculture was king. This development created an increasing amount of river traffic, and with it came the growing realisation that Norfolk's waterways needed better navigation. By 1670 an Act of Parliament had been passed enabling improvements.

By the eighteenth century the Broads and the rivers that link them were busy waterways. The wherries had emerged as the workhorses of a commerce that shipped the produce of the booming agricultural output. And yet, the population of Norfolk was not growing in line with the rest of the country. The reality was that the once pre-eminent agricultural heartland was becoming secondary to the great industrial revolution that would change the nation forever, and have an unprecedented effect on Norfolk and the Broads.

With a manufacturing economy and an era of engineering innovation came the railways. A new workforce wanted to break out of their day-to-day existence, and they could, because they were mobile.

When the railways arrived in Norfolk in 1844, the Broads took a ticket to their future. Initially rail passengers began to notice the Broads on their way to the resorts of north Norfolk. The Victorians were falling in love with the outdoor life and rural tranquillity. It was a welcome contrast to their increasingly demanding lifestyle, and at Wroxham station they saw a point of entry to a world that suited them. It suited local business too. Very soon John Loynes saw

a market for hiring out his boats, and Roys saw the commercial potential in supplying the necessary provisions.

When the twentieth century arrived, the Broads were almost leading a double life. As the trains poured their passengers into the emerging tearooms and inns, and the boatyards engaged with the fledgling Broads holiday industry, others trod a more measured pace. The marshmen were still making their, albeit disappearing, living from cutting the reeds and tending their cattle. Captured in art and photography as the 'real' Broads life, they would soon all but disappear; but in the early twentieth century they clung on as a link to earlier times.

In the meantime a man called Harry Blake had added a touch of modernity to the Broads. Having struggled to book a boat for himself and some companions, he had the idea of acting as a booking agent. Before the First World War had shattered the calm of Edwardian England he'd run a tentative advertising campaign and, arguably, invented the modern holiday boat-hire business on the Broads.

In the 1920s, with peace briefly restored, the Broads came into their own. Regattas and sailing clubs for the locals, holidays for visitors, and evolving boat design saw the area enjoy fame and fortune. It all came to a grinding halt with the Second World War, however, when the Broads were all but shut down, largely through fear of invasion. Wartime needs had meant that some boats were used as temporary accommodation and one man, charged with organising that, saw that with peace in 1945, there was an opportunity. His name was Hoseason.

Driven by his son the Hoseason business became a legend. From the 1950s onwards Blakes and Hoseasons were the catalysts for the real development of Broads boat hire. Sophisticated marketing aimed at a post-war generation with a newfound affluence and paid-for holiday time delivered outstanding results. The Broads were now a playground.

The balance between man and nature came more sharply into focus than ever before. Nobody could dispute the work, profits and commerce generated by tourism. But in terms of the region's natural habitat, what was the cost? The conservation question was now on the agenda. So too was research. Doctor Joyce Lambert had been publishing findings since 1946. In 1952 her colleague, J. N. Jennings had published his *Origins of the Broads* in which he claimed that, although there might be some exceptions, the Broads were a natural phenomenon. Lambert, however, had carried out different tests. She found that the Broads had flat beds, vertical sides and pathways through them. It was all linked to peat digging. She went public with her controversial findings: the Broads were man-made.

Knowing more about their past, however, was not answering questions about the Broads' future. Despite work done over decades the fact was that the preservation of the area was now a real issue. Through tortuous legislation and debates at a national level, the agreed need was for a cohesive and caring management of the waterways. Eventually it arrived in the form of the Broads Authority.

Horsey Mill. (Courtesy: the Broads Authority.)

Wherries on the Broads. (Courtesy: the Broads Authority.)

St Benet's Abbey. (Courtesy: the Broads Authority.)

And now, in the twenty-first century, the balance between conservation and recreation, commerce and nature, is perhaps more finely adjusted than ever before. There is a supreme irony in that the waterways we seek to protect from man's intrusion are themselves man-made.

But, the Norfolk and Suffolk Broads, to give them their full title, are a place of wonder. They are Britain's largest protected wetland and the country's third largest inland waterway. Hugely popular as a holiday destination, they provide leisure, employment and a fantastic environment for wildlife.

27. The Norfolk Wherry Trust

Before looking at the Norfolk Wherry Trust, it's important to consider the wherry itself. This craft is an essential part of Norfolk history, and so inextricably linked to the county's heritage that its familiar shape is almost an emblem for Norfolk.

The absolute origins are lost, but by the early seventeenth century there were wherries carrying cargo and passengers around Norfolk and Suffolk. A larger version was known as the keel; while its history could stretch back even to the Vikings, its characteristic large sail mounted amidships is the blueprint for the wherry as we think of it.

By the nineteenth century the old keels were all but extinct as the trading wherries that developed from it were more manoeuvrable and needed fewer crew. The great sails, blackened with tar and fish oil to protect them from the elements, were a common site on the rivers and Broads of Norfolk.

It was the advent of the railways that took the cargoes so important to the wherry traders away from the water. *Ella*, the last trading wherry, was built in 1912. Keen to replace their lost income the wherry men diversified, ironically to cater for the same, fast-developing tourist market that was the railway's other main business. Seeing that the craze for the Broads and water-borne holidays was

Wherries. (Courtesy: the Broads Authority.)

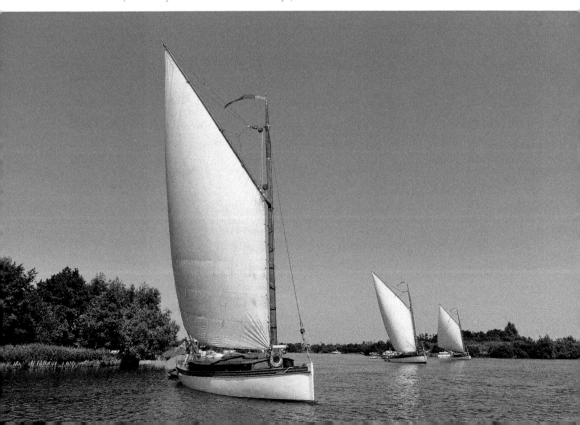

a growth area, many skippers converted wherries to pleasure craft. Initially these conversions consisted of little more than stringing-up a couple of hammocks, and possibly adding a stove to cook food. But, such was the potential for tourism that it wasn't long before custom-built 'pleasure wherries' were being constructed with cabin space instead of cargo holds, while retaining the distinctive hull shape and rigging for local authenticity.

Another development would follow: to distance the pleasure craft even further from the trading wherry, and deliver a more refined experience for the holidaymaker, the 'wherry yacht' emerged. Its sleek, usually white, hull was impressive, and the seating arrangements meant that customers could enjoy the views, without getting involved in any actual boating work.

It was all a long way from the old trading days, the huge masts of the wherries being lowered as they navigated bridges, and swinging back up on their counterbalances, the skyline punctuated by dozens of the giant sails. Even the tourist boats were suffering as the twentieth century moved on between the world wars. By the 1940s the glory days were over. Indeed some wherries were sunk to shore up riverbanks; some became little more than barges.

There were those who felt that the legendary black sails must not totally disappear, and in 1949 a meeting was called at a bookshop in Norwich to discuss plans. A letter was published in the local press, suggesting the formation of a trust to preserve at least one wherry. The reaction was astonishing. An open meeting was arranged and those attending agreed wholeheartedly, and unanimously, that such a trust be established. Under the chairmanship of a Mr Humphrey Boardman the Norfolk Wherry Trust was instigated, instantly becoming an unprecedented organisation; nobody had ever formed a trust – in effect a group of volunteers, with the sole intent of avoiding the extinction of a particular type of craft, by obtaining and operating one.

The Norfolk Wherry Trust was born, and soon it had found the fifty-year-old wherry *Plane*. She had originally been called *Albion* and now lay moored near the Carrow works of her owners, Colmans, of mustard fame. She would be refurbished by the trust, given back her old name, and sailed. By October 1950 *Albion* had sailed over 2,000 miles, carried over 1,000 tons of cargo, and earned £460. With money still owed for the refit the future looked daunting, but the trust carried on.

By the early 1950s it was becoming obvious that the future did not lie in commercial cargo. Just as the old skippers had done, the trust turned their attention to people and leisure. By 1961 *Albion* was no longer a cargo-carrying vessel.

By 1981 the trust had built a new base for wherries at Womack Water near Ludham. It's thanks to the trust that a wherry sail can still be seen on Norfolk's waters. Today *Albion* carries passengers throughout the holiday season, often being chartered by groups eager to learn skills and experience the thrill of being aboard a real Norfolk wherry.

From its base in Ludham, the trust actively seeks new members and does great work to promote the upkeep of *Albion* and the history of the Norfolk wherries.

Chapter 3: Norwich

There are, of course, entire books written about Norwich, but its inclusion here among Norfolk's gems is essential. The main city of Norfolk, renowned worldwide as 'the Fine City', Norwich is at the very heart of Norfolk.

It's an ancient place, but it was by the time of the Middle Ages that Norwich had become England's second city, bowing only to London in importance. Fuelled by the cloth trade, and populated largely by Flemish weavers who had been actively encouraged to come to the city to rejuvenate trade, Norwich flourished. Its commercial roots, however, stretch back before then. There's been a market in Norwich since before the Norman Conquest in 1066. In fact it was the Normans who moved the original market to where it stands today; they wanted the original site for their magnificent cathedral. The new market quickly established itself as a trading place to supply provisions for the Norman merchants who were beginning to populate the area.

By the Middle Ages, largely due to the influence of the Freemen of Norwich, the market was already laid out, more or less, in the form it's in today, although none of the structures were permanent. The operation of the market was overseen by the king's clerk. That changed in 1341 when Edward III granted the franchise of the market 'to the city in perpetuity' to say thank you to the city for paying for its defensive walls.

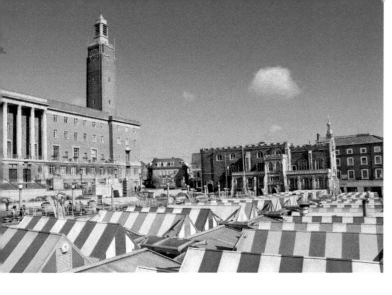

City Hall, the market, and Guildhall, Norwich. (Courtesy: Daniel Tink.)

Under the control of the city the market became well managed. Systems of consistent and fair weights and measures were established, restrictions on the times of day that foodstuffs could be sold were imposed, and unauthorised trading in places other than the market was actively discouraged. Sadly, none of this civic responsibility could prevent the great plague of 1349 – the Black Death. With half of the region's population dead the largely agricultural economy crumbled. That in turn led to famine.

The market's recovery was not instant, but it was robust. By the mid-1560s the place was a major trading centre, selling not only local produce but imported fruits and delicacies.

Although the buildings around it have altered over the years, the market still spreads itself out, at the heart of the city, in front of the City Hall, and next to the ancient Guildhall.

The cathedral, which the Normans built on the site of the original Saxon market, is a magnificent structure. Construction began in 1096, and the materials used included both local flint and limestone from Caen. By 1145 it was complete, including the towering spire that still dominates the Norwich skyline. The cloisters are the second largest in England, surpassed only by those at Salisbury Cathedral.

Norwich Cathedral has a colourful history and information is readily available to visitors, who will find it both impressive and fascinating. Like the castle, also built by the Normans, it's been a constant throughout centuries of the city's changing fortunes. Less prosperous for a while when the Industrial Revolution shifted the manufacture of cloth to the North, the city re-emerged to become a major manufacturing base, and is now a world renowned financial, arts and technology centre.

For the visitor there are numerous attractions. The centre is very self-contained, and the market, cathedral and castle are all within walking distance of each other.

An integral part of the city centre is the area now known as the 'the Norwich lanes', and it's here that you'll find shops, galleries, museums, cafés and bars – many of them small independent enterprises. Although that's not to say that the city doesn't have its fair share of national retailers.

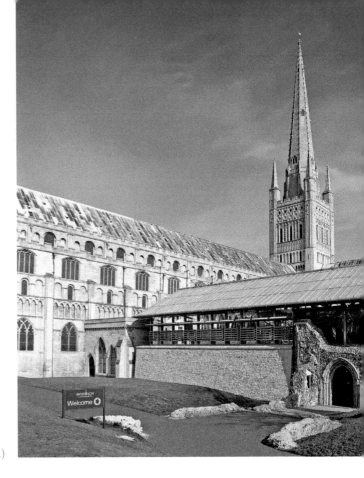

Norwich Cathedral.
(Courtesy: Paul Hurst ARPS.)

The juxtaposition of ancient buildings like the Guildhall with impressive modern architecture such as the Forum adds to the joy of the city centre. Surprises are everywhere. The Royal Arcade, for instance, is a magnificent art nouveau thoroughfare created by the Edwardian architect from East Dereham, George Skipper. And Elm Hill, arguably one of the most photogenic streets in England, is a joy.

Culturally Norwich is a thriving city. Arts and entertainment have flourished in recent times; major theatrical productions and appearances by leading music stars are regular features. As is, every May, the Norfolk & Norwich Festival. It's one of the top four UK-based international arts festivals. Every year over 75,000 people immerse themselves in a huge programme of world-class music, theatre, literature, visual arts, circus, dance and outdoor arts, in dozens of venues.

Academically the University of East Anglia is highly respected, and it too is world renowned for its post-war architecture.

Commercially the city is now a leading centre for insurance, finance and a range of innovative businesses, upholding the tradition started by companies who were created here, including Barclays, Norwich Union (now Aviva), Colman's and Start-Rite.

Norwich is a city steeped in history, yet fiercely alive and in tune with modern commerce. Its culture, too, blends traditional and cutting-edge entertainments. Accessible, fascinating, welcoming and rewarding – it really is a 'fine city'.

32. Julian of Norwich

Deviating slightly from the alphabetical listing of these fifty gems of Norfolk, it's important to include Julian of Norwich. She is important because there is a version of her *Revelations of Divine Love*, usually known as 'the Short Text' – which is perhaps misleading as it's some twenty-five chapters and 11,000 words long – that earns her an important place in history. It is believed, and usually now acknowledged, to be the earliest surviving book written by a woman in the English language. Yet considering that substantial claim to fame, we know little of her early life. We believe that she was born around 1342 and died around 1416. The *Revelations of Divine Love* appear to have been written in 1395.

Her lifetime coincides with Norwich's time as the second most important city in England, and she may well have come from a privileged family. There is still speculation about her education, and whether or not she was a nun, or possibly widowed by the plague, outbreaks of which were common at the time.

What we do know is that she became an 'anchoress', choosing to isolate herself from the world in order to live a life of solitary prayer and contemplation. Even her real name remains unknown, but in becoming an anchoress she lived in a cell built against the wall of the Church of St Julian in Norwich. It's possible that the decision to live alone in her cell was made, in part, to serve as a form of quarantine because of her proximity to the plague.

Her book is the direct result of events that we can date more precisely. We know that when she was thirty, and before she withdrew, she was struck with a serious

Julian of Norwich.
(Courtesy: the Julian Centre.)

illness and given the last rites on 8 May 1373. As the curate held the crucifix above her, Julian saw a vision. Despite what she perceived as failing eyesight and an overwhelming numbness, she saw Jesus, on the crucifix, and she saw him bleed.

Between that point and 13 May 1373, when her illness subsided, she had sixteen more visions of Jesus. It was these that she recorded straightaway, subsequently rewriting them to become the *Revelations of Divine Love*. Years later, possibly in the 1390s, she explored the meaning of these visions in more detail and produced some 63,000 words, now known as 'the Long Text'.

Even allowing for the gaps in our knowledge about her, Julian of Norwich remains timelessly and international famous for her writings, and is seen as one of the 'creative theologians, spiritual writers and mystics in the Christian tradition'.

The Church of St Julian was bombed in 1942, when Norwich withstood considerable enemy action, but a new one was built on the same spot in the early 1950s, and reconsecrated in 1953. Next to it is the Julian Centre. Pilgrims and visitors regularly visit it from all over the world, as they do her shrine in nearby Rouen Road.

Perhaps the most famous quotation from Julian's works is, 'All shall be well, and all shall be well and all manner of thing shall be well.' It's a testament to the hope and positivity that seem to have hallmarked the life of this extraordinary woman who, despite her solitary regime, remained a stalwart counsellor of those seeking comfort.

The Julian Centre. (Courtesy: the Julian Centre.)

Chapter 4

33. Overstrand

A stone's throw from Cromer, Overstrand is a gem of north Norfolk. Once a small fishing station known as Beck Hythe, today it's a lovely village with a population of around 1,000.

Overstrand has played an important part in the growth of awareness of north Norfolk, and it's largely because of one man – Clement Scott. He was a travel writer and journalist, and very well connected with London's theatrical world and social elite. In the 1880s he visited Overstrand and was totally smitten with it. It was he who coined the name 'Poppyland' for the surrounding area – a name still in use today.

He wrote enthusiastically about his newfound Norfolk idyll, and as a direct result of his articles the rich and famous began to visit Overstrand. Such was its popularity with them that some bought or had houses built there, earning the place a name and reputation as 'the village of millionaires'.

And there were indeed some millionaires among the new inhabitants of Overstrand, even if some were part-time. William Player, of the tobacco company, purchased the Grange in 1910. The same house was later bought by Sir Jesse Boot, founder of Boots the Chemists; and Henry Royce, of Rolls-Royce, lived at Overstrand, in a house called Pump Cottage.

Perhaps less well known, but decidedly wealthy, was another resident, Sir Edgar Speyer. He was a London banker, who was also chairman and founder of the London Underground. In 1908 he built a country home for himself in Overstrand. It was a classic Edwardian mansion and stands today as the Sea Marge Hotel. It would earn Sir Edgar and the village a footnote in Norfolk, and national, history.

In the First World War Sir Edgar was suspected of being a German spy; it seemed he had allowed his mansion to be a signalling point for German submarines. Stripped of his knighthood, he was eventually deported.

His mansion would eventually open as a hotel in 1935. For a while after the 1950s it was a nursing home, and eventually reopened as a hotel again in 1996; today it remains a splendid and popular place.

Earlier, and interestingly with another First World War connection, Winston Churchill's mother had stayed at the Sea Marge and taken the young Winston there in 1885. He must have liked Overstrand because he returned, this time to stay in a rented cottage with his wife and family. It was a holiday that would be cut short. On Sunday 26 July 1914 it was from Overstrand that Churchill telephoned the First Sea Lord and realised that international events were now so serious that he was needed back in London. He left Overstrand for the last time on an admiralty yacht and a few days later, on 4 August 1914, we were at war with Germany.

The proliferation of rich clients meant that some important architects worked on projects in Overstrand, and none more famous than Edward Lutyens.

Oddly, one of his important buildings in the village is not a house. It's the Methodist Chapel. Built in 1898, the chapel is Grade II listed. Its significance is its style. The architectural historian Pevsner pointed out that the design of it, which includes a certain functionality, was very modern. In fact it's an early example of modernism – a style that by the 1930s would be all the rage across Europe.

Overstrand has another military connection. The First World War had seen the emergence of the biplane bomber. A direct descendant of those aircraft was built by Boulton and Paul in Norwich. They called it the Sidestrand – named after Overstrand's neighbouring village. By the 1930s they'd developed an improved and upgraded version, which they called the Overstrand. It would be the Royal Air Force's last twin-engine biplane bomber. Some of them remained in service until 1941.

View from the Sea Marge Hotel. (Courtesy: the Sea Marge Hotel.)

Spies, wars, and bombers are no longer a worry in this tranquil and charming village but there does remain one threat: coastal erosion. It's a constant battle to stop the sea washing away the beach. Much work has been, and is being, done to halt it. It's important work because this is a lovely place. With its shops, and pubs and clifftop café, it's a wonderful place to visit, and as a base for a holiday to explore further.

34. Oxburgh Hall

Oxburgh Hall is a Grade I-listed building, which, as the highest designation there is, indicates its importance.

Although it is a moated great house, it has never been a fortress. It's been a family home since it was built by Sir Edmund Bedingfeld around 1482. Oxburgh, as a manor, had come to his family through marriage some time before 1446. In 1482 Sir Edmund had received the license to crenellate – this came from the king and allowed a gentleman to fortify his house by providing it with battlements. Although the fortifications at Oxburgh are more for display than battle, Sir Edmund used the permission to construct this fine house, and his family have lived there ever since.

The house was altered considerably in the late eighteenth century for Sir Richard Bedingfeld, and then again in 1835 when some of Sir Richard's modifications were addressed, effectively returning the design to a house with a central courtyard. The Victorians, as they often did, added more gables, windows and towers.

Oxburgh Hall. (Courtesy: www.tournorfolk.co.uk)

The Bedingfelds' Catholic faith exposed them to possible persecution during the sixteenth century and Oxburgh has a wonderful example of a priest hole – a small hidden chamber with a secret door in which they would have hidden if the house was raided.

Today the hall is owned by the National Trust, and the well-tended grounds are a delight. They feature woodland walks and trails. But back inside the house is another of Oxburgh's true treasures. The Oxburgh Hangings are astonishingly beautiful needlework hangings by Bess of Hardwick and no less a person from history than Mary, Queen of Scots. The women worked on this needlework while they were prisoners, held by the Earl of Shrewsbury. A truly remarkable antiquity in as fine a medieval moated house as you'll find anywhere.

35. Reepham

Really ancient history doesn't have too much to say about Reepham, although its neighbouring parish shows up in early writings, and apparently the two places shared a priest and a church.

In stark contrast, when Reepham does appear in the history books it's famous for being one of only two places in Europe to have three churches on the same site. By then Reepham was definitely a market town, as we know that it been granted that status by 1277. One of the three churches burnt down in 1543 and only fragments remain, but today Reepham's Church of St Mary is joined by its choir vestry to St Michael's.

Although never quite as important as Walsingham, Reepham was an important place of medieval pilgrimage. The Shrine of Our Lady of Reepham was seen as a place of miracles. We know little of why this was or what form these miracles took, but certainly in the fifteenth century a lady called Alice Cook of Horstead recorded that after she had died she would want a man to 'goo a pilgrimage to our Lady of Reifham' because she believed that this would ease her passage to the next world.

If the shrine is a mystery, it seems that the three churches are the subject of a legend. It was said that they were each built by one of three sisters. The fact is that the buildings were erected over such a long period of time they couldn't have been constructed during the lifetimes of three siblings.

As if three churches was not claim to fame enough, Reepham once boasted two railway stations. In the 1880s the town was served by the Midland & Great Northern Railway, whose Whitwell station at Reepham was a stop on the journey from Norwich to Melton Constable. The other station was on the Great Eastern Railway's line. The trackbed where the Midland & Great Northern line ran is, as has been mentioned elsewhere in the book, now part of the popular Marriott's Way footpath.

Above and below: Reepham Festival. (Courtesy: Reepham Festival.)

Reepham's market square is everything a small town's centre should be. Although it is a thriving modern community, the town does have a period charm. So much so that it was used as the location for the filming of an episode of *Agatha Christie's Poirot*.

As to entertainment with a more modern twist, Reepham plays host to its own annual festival. From small beginnings this has now grown into a major event in the calendar, attracting top entertainers and huge crowds.

36. The Royal Norfolk Show

The Royal Norfolk Show (or as it's often referred to locally, the Norfolk Show) is an institution. Its real beginning probably stretches back to the days of the trading fairs when, even in pre-medieval England, people would gather to combine the buying and selling of goods with entertainment.

By 1937 the Royal Agricultural Association of England had been founded and Norfolk was represented from the outset. Two of the original member associations – the East Norfolk and the West Norfolk – merged in 1847 to form the Royal Norfolk Agricultural Association, and the Norfolk Show was born.

For fifteen years the show was put on alternately at Norwich and Swaffham. Then, in 1862, a new format was introduced. The Norfolk Show was held at various sites throughout the county, supported by land owners. This would remain as the tradition until 1953. By then it was the Royal Norfolk Show, having been granted the all-important prefix by Edward VII in 1908. He'd accepted the presidency of the show some years before, in 1872, when he'd still been the Prince of Wales.

Since 1953 the Royal Norfolk Show has been staged on its permanent site at Costessey, just outside Norwich. Across all of the years there have only been a few gaps. For instance, no shows were put on during either of the world wars. The 1866 show was cancelled because of cattle plague. In more recent times the 2001 show was also cancelled, owing to foot and mouth disease.

The Royal Norfolk Show. (Courtesy: the Royal Norfolk Show and Andy Davison.)

The Royal Norfolk Show. (Courtesy: the Royal Norfolk Show and Andy Davison.)

Today the Royal Norfolk Show is a vast enterprise. One of only eight such shows to hold the royal warrant, it's now the largest two-day agricultural show in England, with around 90,000 visitors a year.

Farmers, breeders, growers and a vast range of businesses are there to display their wares and showcase the best of Norfolk. There are hundreds of stands, from clothing to vehicles, and lots of opportunities to sample the county's food and drink. Live demonstrations include not only the events in the show's main ring, but also cookery events from leading chefs. It's estimated that there are over eighty hours of action across the two days. And at the heart of it all is charity, with the annual Royal Norfolk Show Ball raising funds for a chosen cause each year.

As much as the Royal Norfolk Show has developed and grown, becoming a major event in Norfolk's calendar, in many ways it retains the essence of those ancient rural fairs. It manages to strike the right balance between agriculture and entertainment – appealing to a wide audience of all ages.

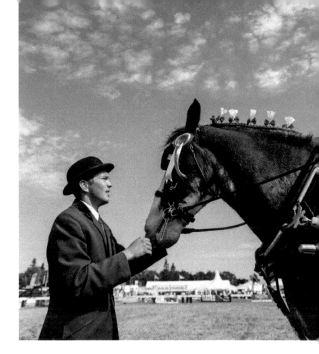

The Royal Norfolk Show.
(Courtesy: the Royal Norfolk Show
and Andy Davison.)

37. The Sainsbury Centre for Visual Arts

The Sainsbury Centre for Visual Arts is an extraordinary building with an extraordinary story. Designed between 1974 and 1976 by the then little-known Norman Foster (who would become Lord Foster), it opened in 1978. Standing on the western edge of the University of East Anglia's campus, next to the River Yare, the building has been said to exemplify Foster's early work, being 'a regular structure embracing all functions within a single, flexible enclosure, or "universal space"'.

The purpose of this 'universal space' is to house the collection of Robert and Lisa Sainsbury. Sir Robert Sainsbury had begun collecting art in 1929, and his first purchase was Jacob Epstein's bronze head, *Baby Asleep*.

Collecting would become a mutual passion when he married Lisa van den Bergh in 1937, and they set about buying pieces from artists they admired, often in the early stages of their careers. They saw collecting as being driven by instinct and placed no importance on value, fashion or reputation. Such was their determination on this point that not only did they befriend artists whose fame was at times fledgling to say the least, they also embraced art from around the world – from Africa, Oceania and the Americas. Sir Robert was forthright in his claims that such works should not unfairly be labelled tribal but that they

The Sainsbury Centre for Visual Arts. (Courtesy: Oxyma.)

should be seen as having equal status to European art. It's a belief that would not only gain greater acceptance, but would also serve as a guiding principle on how the collection is displayed today.

The thousands of items in the collection contain works from all over the world, and from all of its history. Over 5,000 years of art are represented by pieces from prehistory to the late twentieth century: ancient artefacts from Africa, Asia, and the Mediterranean cultures of Egypt, Greece and Rome sit alongside work from medieval Europe. They are all juxtaposed with modern European art, as the Sainsbury Collection contains pieces by the likes of Jacob Epstein, Henry Moore, Picasso, Edgar Degas, Francis Bacon, Giacometti and Modigliani. It has been described as, 'one of the few intact modernist collections of the 20th century.'

This great labour of love was to become a great gift. Sir Robert and Lisa Sainsbury donated this massive, internationally important collection to the University of East Anglia in 1973. And still the collection grew. Indeed after Sir Robert's death in 2000, Lady Sainsbury carried on the work of collecting until 2006.

After the donation to the university it was Sir Robert's and Lady Sainsbury's son David who funded the astonishing building to house it on the campus. The building is also home to the School of World Art Studies & Museology.

Given the project to undertake, Norman Foster would employ his signature methods of 'design development' and 'integrated design'. Of the work, he would later say that, 'A building is only as good as its client and the architecture of the Sainsbury Centre is inseparable from the enlightenment and the driving force of the Sainsburys themselves, and the support of the University of East Anglia.'

On the inside, the collection is a staggering sight. Wonderfully displayed and curated, it offers an exciting and eclectic journey through time and art,

uninterrupted by needless divisions. From the outside the building itself is hugely impressive. With one face almost entirely of glass, its skeleton is visible. And, like the collection itself, it has grown. When, in the late 1980s, Foster was asked to extend it to house even more artefacts, he took the adventurous step of going not outwards, but downwards. Opened in 1991, the extension is, in effect, a basement built into the sloping site, with a curved-glass front looking out over a man-made broad, which references the nearby and ancient Norfolk Broads themselves.

When you're in Norfolk, the Sainsbury Centre for Visual Arts is an essential place to visit. If you've not been there yet you may, unwittingly, have seen it. In April 2014 the staff at the Sainsbury Centre received a call from a film production company who wanted to visit the site as a possible location. In the June, after a pre-filming recce by production staff, the actors arrived. They included Robert Downey Jr and Scarlett Johansson. The film was *Avengers: Age of Ultron*, the sequel to the third-highest-grossing film of all time. When the film was released, the truth was revealed: the Sainsbury Centre is the base of operations for the Marvel superheroes.

38. The Sandringham Estate

Sandringham has been the private home of British monarchs since 1862. It's a tradition that has continued into the twenty-first century, as it is currently the country retreat of Elizabeth II.

The estate is often referred to as being 'much loved' by the royal family. It's a sentiment that's endorsed by the oft-quoted remark of George V: 'Dear old Sandringham, the place I love better than anywhere in the world.'

Sandringham House. (Courtesy: www.tournorfolk.co.uk)

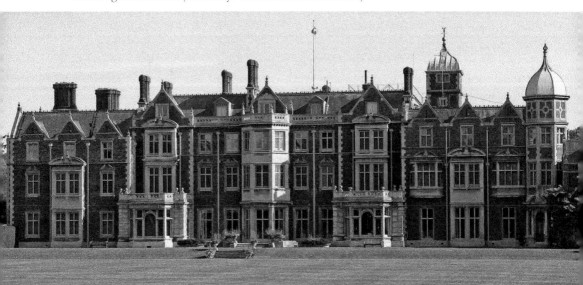

Princess Alexandra was the catalyst for Sandringham becoming a royal home. Edward VII, when he was still Prince of Wales, asked Queen Victoria to buy the hall in 1862 as a home for himself and his new wife, Alexandra. Norfolk's landscape would, he thought, remind her of the countryside near her home in Denmark. Edward would subsequently have the place demolished and a new building, commissioned by him, was completed in 1870. It was state of the art, with flush lavatories (or 'water closets') and gas lighting. After Edward VII died, Sandringham became the holiday home for the monarch's family.

In February 1952 George VI died there and his daughter, Elizabeth II, has always spent the anniversary of his death, and her accession, at Sandringham. It's seen as a private time for her, although the house in effect becomes her official base during that period.

Diana, Princess of Wales, was born and grew up in Park House, near the Sandringham Estate and, in a coincidence of history, years later when she was married to the Prince of Wales, would spend Christmas with the royal family at Sandringham.

The house is surrounded by some 24 hectares of beautiful gardens, themselves part of the 8,000-hectare estate. It's a varied and yet very 'Norfolk' landscape, stretching out to tidal mudflats and the Wash, and covering environmentally important wetlands. A large part of the grounds, covering heath and woodland, make up the country park, which is open to the public and receives thousands of visitors every year.

The estate itself is financially self-sufficient, encompassing livestock and arable farms, as well as commercial and residential properties.

Given that it is a privately owned residence of the royal family, Sandringham is perhaps Norfolk's most important stately home. But it's always seen as a friendly and welcoming place to visit. It's staffed by expert guides and, aside from the house and gardens, includes a museum full of royal memorabilia. A visitor centre and restaurant add to the overall appeal of the estate as somewhere to have a day out.

Sandringham House gardens. (Courtesy: www.tournorfolk.co.uk)

Steeped in royal history as it is, Sandringham is very much part of the modern world. Hosting private and corporate events, growing and farming using highly sustainable methods, and offering online purchasing, it's carried on the tradition of modernity set by Edward VII's building.

39. Scolt Head Island

This place is a gem of Norfolk, but it's quite a hidden one. Scolt Head Island, 10 miles or so from Wells-next-the-Sea, is only accessible during the spring and summer. But, for the intrepid visitor, the rewards are enormous. The ever-changing barrier island between Brancaster and Wells is a 4-mile strip of Norfolk at its most natural. It's a place of salt marsh, sand dunes and mudflats. It's a habitat packed with flora and fauna of international significance. And it's a place that's moving. Almost certainly once a spit, the island is slowly shifting westwards, dragged by longshore drift.

So ancient is Scolt Head Island (or what is now an island) that we have evidence of people living here 100,000 years ago – in a time of ice and a different landscape.

The weather has often punished the landscape of Scolt Head, even in recent times. In the 1930s storms swept away 250 yards of the island. It was hit, too, in the great storm of 1953 when the sea pounded the Norfolk coast with disastrous results. And yet, although it's been altered by the tides and bad weather, in the summer this is a glorious spot.

Scolt Head Island. (Courtesy: chuckhauptphoto.)

The ferry from Burnham Overy Staithe is the way to get to Scolt Head Island. In theory it's possible to walk from Brancaster Staithe at low tide, but that's not for the inexperienced. Once on the island, its rugged beauty becomes apparent. Plants grow here having adapted to the demanding environment, making them all the more rare. Terns come here in numbers of international importance. Inevitably, and rightly, such a place is protected. It was originally bought by the National Trust in 1923 as a nature reserve, and by 1986 was part of the North Norfolk Coast Site of Special Scientific Interest (SSSI). It's now part of the Norfolk Coast Area of Outstanding Beauty.

Emma Turner, the renowned ornithologist was the first 'watcher' on the Scolt Head Island Reserve, staying there in the 1920s. Twenty years later, in the Second World War, the island would be used as an artillery range. Overall, though, Scolt Head Island hasn't been inhabited or spoiled much by humans. It's a rare and exciting opportunity to see the natural wonder of coastal Norfolk.

40. Sheringham

Sheringham has a motto, granted to it in 1953; translated from the Latin it reads, 'The sea enriches and the pine adorns.' It's a very fitting phrase for this Norfolk town that's as close to woodland as it is the sea.

Once the town we know as Sheringham was the village of Lower Sheringham. Between them the two villages of Upper and Lower Sheringham had a mix of agriculture and fishing as their staple industries. As is the case with so much of north Norfolk, the fishing industry developed rapidly from the mid-nineteenth century when the railways made transport and marketing so much easier.

In fact, arguably, Sheringham is a 'railway town'. The company mentioned in several other gems of Norfolk – the Midland & Great Northern Joint Railway – came to Sheringham in the second half of the nineteenth century and its impact is still there to be seen in the buildings from that period. Interestingly, given that the town is a quintessential part of north Norfolk, it's often commented on that Sheringham's buildings, even though they are largely of flint, are not quite of 'typical Norfolk' design.

Buildings aside, the railway still thrives. Sheringham station is run by the North Norfolk Railway and it's alive with steam and period charm. It's a very popular spot!

That other great constant thread through Norfolk seaside towns is the lifeboat. Sheringham is said to be possibly the only town in the world to still have four of its original lifeboats. The museum in the town, known as the Mo Sheringham Museum, is actively involved in preserving them and other artefacts of fishing

Sheringham. (Courtesy:
www.tournorfolk.co.uk)

and sailing life. Another unusual, if not unique, aspect of Sheringham's lifeboat is that it has to be launched by tractor – the town has no harbour.

It does have a thriving heart and active community though. A really popular place with holidaymakers, the town has lots of shops and cafés, and the Sheringham Little Theatre. This long-established institution puts on productions throughout the year but always has a summer season and a Christmas pantomime. Other annual events are the Cromer & Sheringham Crab/Lobster Festival, which the two towns put on every May, and Sheringham Carnival is always held at the start of August.

And one final point on this lovely town: it has its own place in the Norfolk dialect. A native of Sheringham, when spoken of in the Norfolk accent, is known as a 'Shannock'.

41. Swaffham

Notable among Swaffham's various claims to fame is that the town's name features in a rhyme that helps define Norfolk. For as long as can be remembered, when Norfolk people meet each other, wherever they are, the rhyme is used. They will say to each other, in the most pronounced Norfolk accent they can muster: 'All the way to Swaffham, three days troshin', all for nothin'.' There are variants. Some will add a final sentence along the lines of 'Thass suffin' hint it?' The translation is generally accepted as meaning that someone has gone all the way to Swaffham to do three days' work at threshing, for no pay. The added sentence implying that's 'quite something isn't it?'

The point is not that Swaffham has any reputation for not paying its workforce. It's that the words allow the best possible use of the Norfolk dialect's pronunciation, and as such they serve not only as a form of salutation to a fellow Norfolk person, but also as a sort of check on their credentials. If they can say (and understand) that rhyme, they must be from Norfolk.

Eric Fowler, who wrote as Jonathan Mardle and was an assiduous collector of 'Norfolkisms', wrote that it was also an example of Norfolk people not being above sending themselves up; a trait they're rather better at than some observers would have you believe.

As to Swaffham itself, it deserves to be known in such a Norfolk-defining way because it is a wonderful example of a Norfolk town. Steeped in history and yet with much current activity, it's located at the northern end of that outstandingly beautiful area known as the Brecks. Fine Georgian buildings edge the market place, which bustles into life every Saturday with country town buying and selling of vegetables, fruit, fish, cheese and all manner of clothes, tools and bric-a-brac.

Like all good market towns this place has a fine church and well-crafted town sign. In Swaffham there is a decided link between them, and that – or he – is the legendary 'Pedlar of Swaffham'.

The story is much told and must be seen as a legend, although there are some factual twists that give the tale credence. The story goes that one John Chapman, a pedlar living in Swaffham, dreamt that were he to go to London Bridge he would, in the time-honoured phrase, 'hear something to his advantage'. Initially sceptical he decided, having had the same dream a second time, to go. Taking his dog with him, he walked from Swaffham to London Bridge and, on arriving there, waited.

Eventually, a shopkeeper who had been watching John for some hours struck up conversation with the pedlar, who told him of his dream. The shopkeeper, taken aback, explained that he had dreamed of there being gold under the apple tree of a man called Chapman in a place called Swaffham – 'wherever that was' – and were he a believer in dreams that's where he would be, digging it up. As he

had no time for such nonsense, his best advice to the pedlar was to go home and forget it. Needless to say John Chapman returned to Swaffham with all haste and dug under his apple tree, where he found a pot containing gold coins!

He stored the coins safely and cleaned the pot. There was an inscription on it but, as he was unable to understand it, he put the pot up for sale on his pedlar's stall. It was there that it was seen by a monk who translated the wording for John. It said: 'Under me doth lie, another richer far than I.' The pedlar returned to his apple tree and dug again. And what he found was another pot; a much larger one, filled with even more riches. The legend ends with the people of Swaffham deciding to restore their church and being pleasantly surprised when the pedlar offers to pay for the north aisle and the tower.

St Peter and Paul's Church in Swaffham is a splendid building. Its double hammerbeam roof is often cited as one of the best in Norfolk, and is a truly magnificent piece of architecture. Not far from the marketplace, the church dates from 1454. Happily we know quite a lot about it being built because John Botewright, the vicar there until the mid-1470s, kept a record known as the 'Swaffham Black Book'. In it he listed all the people who contributed to the work of building the church. The donation to build the north aisle and steeple tower is listed as being made by Mr and Mrs John Chapman. You'll find the 'Pedlar of Swaffham' commemorated both inside the church and on the town sign.

Its marketplace heart, wonderful church, attractive buildings and fascinating legends aside, Swaffham has quite an impressive roll call of past inhabitants. Towards the end of the nineteenth century the nearby Didlington Hall was the home of Lord and Lady Amherst, and they would often employ the talents of Swaffham artist Samuel Carter to paint their animals. Samuel's son would go with him and the boy became fascinated in the Amherst's fabulous collection of Egyptian antiquities. It became an obsession; the lad would go on to work for the Egypt Exploration Fund, before forming a partnership with Lord Carnarvon, who would fund exploratory expeditions.

In 1922 the young man, backed one last time by Lord Carnarvon and against the better judgement of many, made a discovery that would shape world history. The Swaffahm lad was Howard Carter, and he'd uncovered the tomb of Tutankhamun.

Other local names of note include Captain W. E. Johns, creator of one of fiction's most famous aviators, 'Biggles', and world-famous national treasure Stephen Fry. Among his vast output of work Mr Fry includes the television series *Kingdom*, part of which was filmed in Swaffham, with the town becoming the fictional, but authentically Norfolk-sounding, Market Shipborough.

Swaffham probably found its first prosperity from the emerging sheep and wool industries of the fourteenth and fifteenth centuries. It shows no signs of failing to grow and develop with modern innovations and is home today to two huge Enercon wind turbines and the Green Britain Centre. One of the turbines features an observation deck, and is the only wind turbine in the world open to be climbed by visitors.

Swaffham town sign – the Pedlar.
(Courtesy: Jim Moon.)

As one more claim to fame, the 2008 British BASE Jumping championships were held at Swaffham when contestants jumped from the roof of the turbine's observation deck. Most visitors are happier to enjoy the fantastic view, being able to see not only the organic gardens but as far as Ely Cathedral.

42. Thursford (and the Christmas Spectacular Shows)

It's unlikely that the Norfolk village of Thursford would have found any fame at all had it not been for the particular interest of one man. George Cushing was born in 1904 and, having left school at twelve, became a farmhand; still a child, he rapidly developed a love of steam engines. By 1920 he was running his own sub-contracting business, driving a second-hand streamroller he'd bought from the local council. The business grew. By the outbreak of the Second World War he had fifteen steamrollers and a wagon.

The Christmas Spectacular, Thursford. (Courtesy: Thursford Enterprises.)

In one sense he was out of step with progress. Steam power had been losing out to diesel lorries since the 1930s, but Mr Cushing was determined to see them preserved. Now the owner of Laurel Farm, where he'd worked as a twelve-year-old, he began buying and restoring condemned steam engines and storing them at the farm.

Word spread and fellow enthusiasts would come to Thursford to see, and help restore, engines. By the 1970s George had a museum open, housed mainly in the old farm sheds. He became a familiar figure, happily talking to visitors as they wandered around the exhibits. George Cushing's wife died in 1976 and, advised that the museum collection would attract death duties when he passed away, he instituted the Thursford Collection as an Endowed Trust Charity.

And still the centre grew. A gift shop was added, along with tearooms. Opening times were extended. *Steam at Thursford*, the book George co-wrote with Ian Starsmore, came out in 1982 and raised the profile of the place still further.

George, who had received the MBE in 1989 for his work on saving the country's steam heritage, lived a long and full life. He sadly passed away in 2003 at the age of ninety-three.

In the hands of his son John the Thursford Collection has gone on to unimagined heights. The exhibits themselves are as impressive as ever and now include the massive 139-pipe Mighty Wurlitzer organ that had once graced the Odeon Cinema in Leeds. Another outstanding item is the merry-go-round, built in the nineteenth century by Frederick Savage in Norfolk.

But, it's the 'Christmas Spectaculars' that have propelled Thursford into the stratosphere of fame. These shows have become a sensation. Acknowledged as the 'largest Christmas Show in the country' the Thursford Christmas Spectacular is three hours of live entertainment. Over 100 dancers, musicians and singers perform among the organs and merry-go-rounds to deliver a show of breathtaking speed and variety.

Fifty or more coaches arrive every day during the run of the show, bringing people from all over the country and abroad. Many stay over in the nearby hotels and guesthouses. Over 100,000 people come to Thursford every year to

Above: The Christmas Spectacular, Thursford. (Courtesy: Thursford Enterprises.)

Left: The Collection at Christmas, Thursford. (Courtesy: Thursford Enterprises.)

see this show – some booking from one year to the next – and any booking has to be made months in advance. It's an extraordinary event. Seasonally favourite songs are mixed with standards and current chart hits. Carols feature too.

It's all a long way from one man's dream of preserving the steam engines he loved. Although Thursford still has steam at its heart, it's the Christmas Spectacular that has grown more than perhaps even George Cushing could have imagined.

43. Jack Valentine

Jack Valentine is someone very well known to Norfolk people, but perhaps less famous elsewhere. He is a very mysterious figure in more ways than one. Firstly, he seems to be unique to Norfolk. He's inextricably linked to the celebration of Valentine's Day but he's not specifically connected to matters of romance. He is never seen.

He certainly falls in line with the Norfolk spirit of 'doing different'; just as New Year's Eve is known in Norfolk as 'Old Year's Night', there is evidence of 13 February being celebrated in the county as 'Valentine's Eve'. Jack, though, seems only to arrive on the night of the 14th.

He knocks on the door and leaves a present on the doorstep, but by the time the door is opened he's disappeared. For centuries Norfolk's children have received gifts from Jack and he's so swathed in history that, in truth, nobody knows much about his origins or why he only operates in Norfolk.

Like most other places, Norfolk has a long tradition of romantic cards and gifts being exchanged between sweethearts, but only here does Jack appear (or not!) to deliver presents to children. He's occasionally been referred to as 'Old Mother Valentine' and sometimes 'Old Father Valentine', but 'Jack' is his most common name. Time was the gifts he left were decidedly home-made.

In the nineteenth century the tradition took a slightly different twist when children would set out before dawn on 14 February to sing rhymes, typical of which was this:

> Good morrow, Valentine,
> God bless the baker,
> You'll be the giver,
> And I'll be the taker.

Their mission was to obtain sweets and gifts in return for their singing. Time, though, was of the essence. If they were still out and singing after sunrise, their requests would be denied as they were deemed 'to be sunburned'.

By the 1950s, although he was still very much at work, as he is today, he seems to have been able to leave presents of a more shop-bought nature. Despite this modernisation of his methods, Jack refuses to go away. Some recent research revealed, for instance, that people who had left the county, including some who had moved to the USA, were determined to ensure that the tradition continues. So much so that some hotels and business groups seem to have enlisted his help in delivering gifts, sometimes of a more grown-up nature, and often involving wine, to guests and customers. Jack seems to be very accommodating in moving with the times while still upholding the most ancient and mysterious aspects of his reputation!

44. Walsingham

Sometimes referred to as 'England's Nazareth', Walsingham has been an important centre of pilgrimage since 1061.

Although strictly speaking a conjoining of Little Walsingham and Great Walsingham, it is, however, small. The 2001 census stated its population as 864 in some 397 households. By 2011 the census listed the population as having declined to 819.

Walsingham is a north Norfolk village and nestles in the countryside around 4 miles from the coast and south of Wells-next-the-Sea. It's a rural place, surrounded by Norfolk farmland where livestock graze and arable fields produce wheat, barley, sugar beet and fruit. These are farms that have passed from generation to generation in a village history that stretches back to beyond its recording in the Domesday Book.

Pivotal in this long history is the year 1061. Richeldis de Faverches was the widow of the lord of the manor of Walsingham Parva, and it's claimed that in that year she was visited by the Virgin Mary. And so begins the legend.

Richeldis was conveyed 'in spirit' to Nazareth – the very spot where the angel Gabriel had appeared to Mary. Three times she saw the vision, during which Mary told her to take the precise measurements of the holy house and use them to construct a precise replica of it at Walsingham.

Local craftsmen were instructed to commence the building, using materials that Lady Richeldis would supply. Accounts vary, but most agree on there having been a problem over selecting and then actually building on a plot. It's said that Richeldis prayed all night for an answer to this predicament.

The next morning revealed that, miraculously, the house had been constructed and completed overnight on a site seemingly chosen by the Virgin Mary herself. Inside this new house, or chapel, was a wooden figure of Mary with the child Jesus seated on her lap. Almost immediately Walsingham became known, and venerated, as one of the most sacred places in England. Pilgrims visited 'Our Lady of Walsingham', asking Mary to pray to Jesus on their behalf.

These pilgrims spread the word, telling of how their illnesses had been cured and their prayers answered. Such was the importance placed on this shrine that in the Middle Ages it was acknowledged that it was the duty of every Englishman to visit 'Our Lady at Walsingham' at least once in his lifetime.

Walsingham was established as a place of enormous religious significance. By the fifteenth century there were only two major sites of pilgrimage: Walsingham and Canterbury. Walsingham was seen as the more important. Inevitably, word of such a place reached the ears of the royal court, and at some point around 1226 Henry III made a pilgrimage there himself. He would return many times, and gave it his patronage. He also set a precedent, and all the kings and queens of England visited Walsingham. Until 1538.

The problem was that Richeldis' son, Geoffrey, had stipulated that there was to be a priory at the shrine. By 1153 a full priory of canons was in place. As such, when Henry VIII implemented his dissolution of monasteries and priories, and effectively banned the visiting of shrines, Walsingham was destroyed. The figure of Mary was removed. The prior in fact consented to, and assisted in, the destruction and was awarded a pension for his efforts. Henry VIII sold the site for £90 to a Thomas Sidney, who built himself a mansion there.

The people of England did not forget Walsingham. During the Elizabethan era a ballad appeared. The author of 'The Walsingham Lament' is unknown, but the sentiments are clear:

> Weep Weep O Walsingam,
> Whose dayes are nights,
> Blessings turned to blasphemies,
> Holy deeds to despites
> Sinne is where our Ladye sate,
> Heaven turned is to helle;
> Satan sitthe where our Lord did swaye,
> Walsingham O farewell!

It would be the twentieth century before there was any significant revival of pilgrimage to Walsingham. There had been some renewed awareness in the late nineteenth century, but the Anglican vicar of the village from around 1921 was instrumental in establishing a new shrine, work on which began in 1931.

Today there are Anglican and Catholic shrines and over 300,000 people a year visit them. The village is thriving as a result, and provides much of interest itself. Outstanding examples of half-timbered medieval buildings stand alongside elegant Georgian architecture. The Wells & Walsingham Light Railway is the longest 10.25-inch narrow gauge steam railway in the world, and Walsingham is well placed as a base from where to strike out and explore the surrounding area.

Walsingham. (Courtesy:
www.tournorfolk.co.uk)

Above left: Walsingham. (Courtesy: www.tournorfolk.co.uk)

Above right: Walsingham. (Courtesy: Saracen 78.)

45. Wells-next-the-Sea

The name itself often invites comment from visitors, especially those from outside Norfolk. It does seem to be rather specific. The reason for the precision of the name is quite straightforward really. The word 'Wells' emerged from ancient origins, including 'Guella', which is how it appears in the Domesday Book, and derives from the wells or springs that rose through the chalk of the area. By the time the town had become known as Wells, and the mid-nineteenth-century holiday boom was in full swing, it was decided to call it Wells-next-the-Sea to avoid confusion with other towns called Wells.

When the Wells & Fakenham Railway opened for business in 1857, they built a terminus in the town and called it 'Wells-on-Sea'. Almost a hundred years later, in 1956, the local district council decided to revert to 'Wells-next-the-Sea'.

Today the town ticks a lot of boxes for both tourists and locals. The lovely beach, with its characteristic beach huts, sweeps along towards Holkham. There's a narrow gauge railway that runs from the town and car parks to the beach and

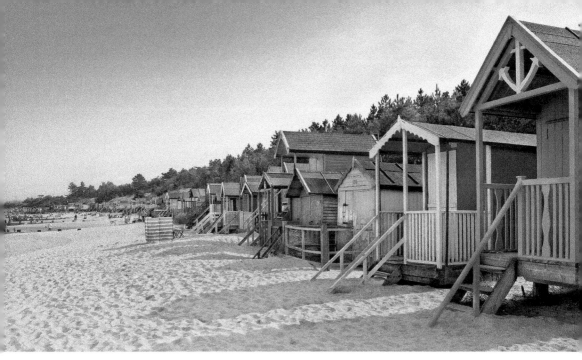

Beach huts at Wells-next-the-Sea. (Courtesy Daniel Tink.)

excellent café. The harbour is classic Norfolk, ideal for crabbing, and it's surrounded by charming little shops and overlooked by the impressive granary, whose gantry soars above the street. A really fabulous place for wildlife and birdwatching, the town is part of the Norfolk Coast Area of Outstanding Natural Beauty.

46. Weston Longville and Parson Woodforde

With just over 300 inhabitants and 150 or so households, Weston Longville is a quiet, less than busy, village. Around 8 miles out of Norwich, it nestles in a landscape of a river valley, wetlands and arable farmland. There is some industry here, including a turkey farm on what was a Second World War airfield.

There's a village hall, a church and, of course, a pub. A pub called the Parson Woodforde. And that's the name that puts Weston Longville firmly into the category of a gem of Norfolk. It was here, in this small village, that Woodforde lived between 1776 and his death in 1803.

James Woodforde was born in 1740 at Ansford in Somerset. He was educated at Winchester College, before going to university at Oxford.

Ordained, he went back to Somerset to be his father's curate for a decade. He then became curate at Thurloxton. When his father died in 1771, Woodforde did not, as

he'd expected, inherit his parish or 'living'. In a difficult period for him he was jilted by his heart's desire, one Betsy White, and failed to obtain the post of headmaster at Bedford School. He returned to Oxford as a sub-warden of his old college and in 1773 they presented him with the living of Weston Longville; worth £400 a year, it was one of the best positions in the college's gift, and Woodforde took it.

Already an assiduous diarist, Parson Woodforde would continue recording daily life in Norfolk until he died. The truly remarkable and genuinely important thing about Woodforde's diaries is that they are accounts of ordinary life. From 1776 onwards they are a glimpse into late eighteenth-century life in Norfolk. We learn of the weather, the births, deaths, illnesses and problems facing ordinary people.

It's often thought that Woodforde was rather too keen on food and drink. It's true that they play a large role in the diaries, but it must be put into context. Woodforde was a country parson and he regularly entertained other members of the local clergy. In keeping with the traditions of the time, as they hosted each other in rotation, the clergymen put on extravagant spreads made up of several dishes. It's wonderful that Woodforde recorded them all, as we have a detailed picture of eighteenth-century entertaining. It's not a given, though, that parson Woodforde ate and drank everything he listed.

He is, however, good at lists, and another vital aspect of his diaries are his accounts. Encouraged by his father to always keep accurate accounts, he has left us a valuable guide to the domestic economics of his times. But it's the anecdotes and insights that matter as much as anything. The comings and goings of the labourers, farmers and servants who mingle in the diary with the clergy and gentry that populate Woodforde's circle.

His niece, Nancy, lived with him as housekeeper until he died, and he seems to have led an enjoyable life as a bachelor parson. He considered Norwich 'the fairest city in England by far' and even in the eighteenth century loved Great Yarmouth's 'sweet beach'.

When his diaries were published in an abridged and edited form in the 1920s by John Beresford, they became immediately popular. Countless editions have followed.

Parson Wooodforde's church, Weston Longville. (Courtesy: Eric Pode.)

Parson Woodforde should be considered an equal of Pepys. He is of immense importance. It's said that Weston Longville takes its name from Longaville in France, and that it was once owned by the Bishop of Bayeux. Bayeux may be famous for its tapestry, but few people have created a better picture of eighteenth-century life, nor woven Norfolk into the fabric of English history, than Parson James Woodforde of Weston Longville.

47. Weybourne

Weybourne is very much a north Norfolk place. It's on the A149 coastal road, not far from Sheringham. It has the countryside-meets-seaside landscape that's, understandably, so popular with walkers and birdwatchers. Within the Norfolk Coast Area of Outstanding Natural Beauty it's a haven for wildlife.

Like so many Norfolk towns and villages, Weybourne features in the Domesday Book. Its early history is quite well documented, including the decreasing assets of its priory, which dwindled until finally disappearing when Henry VIII did away with the monasteries altogether.

It's the Second World War, though, that earns Weybourne an extra couple of notes in history's pages. The first is connected to the North Norfolk Railway. This wonderful steam railway preservation project operates the Poppy Line, which runs from Sheringham to Holt and passes through the beautifully preserved Weybourne station. Less than a mile from the centre of the village, the station was originally built in 1900 and the North Norfolk Railway have done

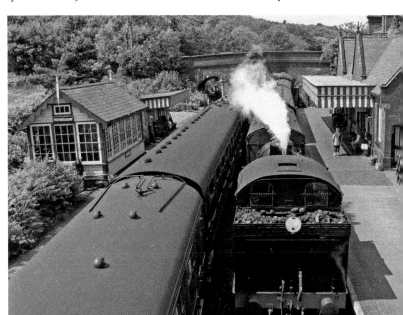

Weybourne station. (Courtesy: North Norfolk Railway.)

an excellent job in importing structures, including the signal box and footbridge, from other stations of the correct period. There's a shop and buffet to complete the picture.

So photogenic is this station that it's often used for filming, and it was here that the memorable 'Royal Train' episode of the legendary *Dad's Army* series was staged.

Secondly, and on a slightly more serious, factual note Weybourne was the location for a mysterious episode in the war. Weybourne was actually thought to be a possible location for a German invasion because of the deep water offshore, and as such was heavily defended with barriers on the beach, and landmines. What's more, Weybourne Camp was a decidedly secret establishment during the war and formed part of the controlled zone set up as part of the anti-invasion precautions.

Despite all of that, or perhaps because of it, there were rumours concerning the occupants of Weybourne Mill. The fine old tower windmill had been built in the mid-nineteenth century and during the war was occupied by a Mr Dodds and his wife, who 'had a strong foreign accent'. Lights had been seen coming from the mill but it seems the local police had taken little or no action. However, one day Mrs Dodds left her bicycle at the tennis courts. It fell over, causing her bag to fall out of the cycle's basket. A local picked it up and looked inside. He found a radio transmitter! Naturally, he informed the police, and a few days later the authorities arrived. They took the Dodds away, and nothing more was heard of them.

Nowadays Weybourne is an understandably popular spot. Its pub, hotel and shops cater for locals and visitors alike, and the place has a real Norfolk charm.

In one final wartime link, the old Weybourne Camp is now home to another popular attraction. The Muckleburgh Collection is the largest assembly of privately owned vintage tanks, armoured cars and military vehicles in the country.

View from Weybourne. (Courtesy: the Norfolk Coast Partnership.)

48. Wiveton

An excuse to discuss the Norfolk dialect!

This sign says it all in a way. The Norfolk dialect is famous for its transpositions of verbs and pronouns, among many other unique features and pronunciations.

The word 'inimitable' is often used as compliment, but Norfolk is perhaps a genuine example of something being seemingly impossible to imitate. Radio, television and film are all peppered with actors trying to 'talk Norfolk', but you'll be hard-pressed to find a performance that passes muster with a Norfolk native. Most attempts seem to place the voice nearer the West Country than East Anglia, and it's the source of much discontent.

To academics the Norfolk dialect is a 'subset of the Southern English dialect group'. But straightaway there are differences from neighbouring accents. For example, for all its being part of a southern subset, Norfolk people do not drop their H's. And the rhythm is different, because in Norfolk some stressed vowels are longer than in received pronunciation (RP) and some unstressed vowels are shorter than in RP. When it comes to grammar, perhaps one of the defining characteristics of Norfolk is in the third-person present tense of verbs, where the 'S' at the end disappears: 'She goes' becomes 'She go'.

From the Singing Postman to a certain manufacturer of turkey products, every once in a while Norfolk, or as the accent is often described, 'Broad Norfolk', has found itself in the national consciousness. This usually results in a brief flurry of awareness, heightened by impersonations (which, of course, are usually inaccurate).

There are definitely some stock phrases that typify the dialect. They would certainly include 'Thass a rummun', which means 'That's rather strange'; and the ever useful 'On the huh', meaning 'that's not level'. Essential to Norfolk speak is 'Hold yew hard,' which translates as 'Hold on a minute', or 'Wait a moment'. Due deliberation is a characteristic in Norfolk and confuse it with being slow-witted at your peril.

Wiveton – 'Slow you down!'
(Courtesy: Keith Osborn.)

Some folk in Norfolk, on reading the above references to southern subsets and RP, would probably call it a 'load of old squit', and there are few better words in any language, let alone dialect, to describe what's perceived as nonsense than 'squit'!

Underlying it all is the Norfolk spirit. The attitude that's proud to 'dew different'. So, if you've arrived in Norfolk, and if you've dared to test your Norfolk credentials (*see* 41. Swaffham) by using the rhyme 'All the way to Swaffham, three days troshin', all for nothin'. Thass suffin' hint it?', you may just want to take it easy, deliberate, in fact it's best that you 'slow you down!'

49. Worstead

This is a Norfolk village, the name of which is more famous than the place itself. Worsted cloth is world-renowned, but its origins in the village that gave it its name are now often overlooked.

Around 5 miles from Wroxham and 13 miles out of Norwich, Worstead was listed in the Domesday Book as 'Wredesteda'. It was given by King Canute to the abbots of St Benet's Abbey, on the River Bure.

The reason for its connection with cloth and weaving goes back to the Norman Conquest, as it's a matter of record that Flemish weavers had begun migrating into the area from that time. Norfolk wool was exported to Flanders, and the cloth made there was then imported back. It was Edward III, who had married a Flemish princess, who encouraged more weavers from Flanders to settle and practise their trade here (or 'exercise their mysteries in the kingdom', as history records him saying).

It was an attractive idea to the weavers. Good quality wool, similar to that in their home country, was in abundant supply, and it's often surmised the flat landscape of Norfolk was pleasantly familiar to them.

The fabric they made was a cloth of well-twisted yarn, spun from the 'long staple' wool with the fibres combed to lay parallel. It was both strong and warm. It was to become known as Worsted, a name now synonymous with the cloth throughout the world. It had certainly achieved a reputation as early as the 1400s. We know because it's mentioned, very favourably, in the famous Norfolk correspondence known as the Paston Letters. Writing to his cousin Robert, William Paston (1378–1444) said,

> I pray that you will send me hither two ells of Worsted for doublets to happen this cold winter, and that ye enquire where William Paston bought his tippet of fine Worsted cloth, which is almost like silk, and if that be

much finer than that ye should buy me, after seven or eight shillings, then buy me a quarter and a nail thereof for collars, though it be dearer than the others, for I shall make my doublet all Worsted, for the glory of Norfolk.

The language is, of course, antiquated. An 'ell' is 45 inches, and 'a quarter and a nail' would measure around 13 inches, but whatever is lost in translation, it's obvious that Worsted cloth was seen as high quality and very desirable.

Norfolk, and Norwich, would build a highly prosperous industry based on weaving. It would last for centuries and be the main reason for the county being so important in pre-Industrial Revolution England. As an indication of the timespan covered by the business of weaving in Worstead it's interesting to note that the oldest Act of Parliament still kept in the House of Lords Record Office dates from 1497, and it is the 'Taking of Apprentices for Worsteads in the County of Norfolk Act'. The last weaver in Worstead was John Cubitt, who died aged ninety-one in 1882.

Today there is an annual Worstead Festival in the village each July, which features demonstrations of spinning and weaving. The production of cloth has long since left Norfolk, becoming part of, primarily, Yorkshire's industrial base as powered looms took over from the old methods and the Industrial Revolution changed the economic landscape.

But, this quiet village can be proud of its heritage in giving its name to the world, from the cloth that made it prosperous.

Worstead Festival. (Courtesy: Roots and Toots Blog, www. rootsandtoots.com)

Above and below: Worstead Festival. (Courtesy: Roots and Toots Blog, www.rootsandtoots.com)

50. Wroxham

Wroxham has been called the capital of the Broads. It's a claim that's rooted not in ancient history but the development of the leisure industry that has become so important to the Norfolk Broads.

To go back into earlier history first, the village, which nestles in a loop of the River Bure, between Belaugh Broad to its west and Wroxham Broad to the east, was certainly a settlement by the time of the Norman invasion. Wroxham's Grade I-listed Church of St Mary the Virgin may have been restored by the Victorians but it is definitely of Norman origin, and boasts a twelfth-century doorway.

Wroxham is famous for its bridge, and that too has history. Records show that a wooden bridge was in place by 1576 and the present one, of brick and stone, probably replaced it around 1619.

By the dawn of the nineteenth century Wroxham was a very rural place. North of busy commercial Norwich, and a good way south of the coast and fishing, it was engulfed in agricultural land. Three interlinked factors would change Wroxham: a growing awareness that the Broads were a place for recreation, the emergence of the seaside holiday, and the arrival of the railways. In short, when the Victorians started to travel by train to the north Norfolk coast for holidays, they looked out of the carriage windows at Wroxham and saw a new playground that suited their growing love affair with the great outdoors. Wroxham became a wonderful entry point for leisure time on the Broads.

Local entrepreneurs were quick to develop boat hire and the supply of provisions for new holidaymakers, and Wroxham emerged as the 'capital of the Broads'.

In a splendidly typically Norfolk way, Wroxham's neighbouring village, Hoveton, on the northern side of the Bure, could make equal claims. Wroxham railway station is officially 'Hoveton & Wroxham' station, and is indeed situated in Hoveton, which is itself officially Hoveton St John. Discussions over exactly where you are, largely defined by which side of the bridge you're on, become academic when you're in this bustling centre of Broadland. It's a place still hugely connected to boating holidays on the Broads and it's the starting point for many a cruise.

The village – or villages – has grown to accommodate the number of visitors and there are numerous restaurants, cafés, hotels, pubs and shops. The most famous among them being Roys of Wroxham, who still claim to be 'the world's largest village store'. Roys were early to see the potential of Wroxham's place in the Broads holiday industry and moved their business there, having started with a general store in Coltishall. Today they're synonymous with Wroxham and the Broads.

People on water-based holidays, like other visitors to the area, enjoy having other things to do as well, and Wroxham's vicinity doesn't disappoint. The Bure Valley Railway is a favourite, as is Hoveton Hall Gardens, and Wroxham Barns

Craft Centre is a delightful mix of shops and cafés. But ultimately it's about the Broads, and Wroxham Broad itself, just a mile downstream from the bridge, is not only popular with holidaymakers but also home to the Norfolk Broads Yacht Club.

The yacht club were partners – along with the Broads Authority and local landowners, Trafford Estates – in an initiative that started in 2000 to halt erosion and improve the Broads' ecology. It was successful, and by 2005 a significant increase in birds and wildlife was reported.

Wroxham Broad is mentioned in two of Arthur Ransome's books set in the Norfolk Broads. You'll find it in both *Coot Club* and *The Big Six*, enshrining the place forever in the history of Broads and boating adventures.

Above and below: Wroxham. (Courtesy: www.tournorfolk.co.uk)

Acknowledgements

As is always the case with writing and compiling a book like this, I have had help from numerous people.

This project began when Amberley Publishing commissioned me to write *50 Gems of Norfolk*, unaware that I was writing and presenting a series for Mustard TV called *Norfolk's Hidden Gems*. Needless to say, some of the 'gems' I'd discovered for the TV programmes made their way into this selection.

Photographers and other organisations have been helpful, and special mention must go to Daniel Tink, Leah Larwood at Roots and Toots Blog (www.rootsandtoots.com), Chuck Haupt (in New York!), M. J. Wase Photography, Alastair Florance at Group Lotus plc, Dr Miles Russell FSA, Byfords of Holt, the Sea Marge Hotel, The Hoste, East Ruston Gardens, the Holkham Estate, the North Norfolk Railway, the Broads Authority, the Julian Centre, Steve Jenkins at the Reepham Festival, the Royal Norfolk Show and Andy Davison, Thursford Enterprises, Keith Osborn, the Norfolk Coast Partnership, Caister Lifeboat, and finally Mark Oakden at the amazing resource that is Tour Norfolk (www.tournorfolk.co.uk)

Occasionally it's proved impossible to find the original photographer or owner of an image. If I've included a picture by you, or owned by you, without crediting you, it's only because I couldn't find you. I hope you'll be happy to see the picture included in the book and accept that I had no intention of not seeking your permission. I tried.

My thanks to the team at Amberley Publishing for their continued help, support and invaluable input.

And, as ever, a special word of thanks to my wife, Sue. Without her constant support and patience projects like this would simply not happen.

About the Author

Pete Goodrum is a Norwich man. He has had a successful career in advertising agencies, working on national and international campaigns, and now works as a freelance advertising writer and consultant.

Pete is also a successful author. His books *Norwich in the 1950s*, *Norwich in the 1960s* and *Norfolk Broads: The Biography*, published by Amberley, all topped the local bestseller charts.

He makes frequent appearances on BBC local radio covering topics ranging from advertising to music and social trends, and is a TV presenter. A regular reader at live poetry sessions and actively involved in the media, Pete has a real passion for the history of Norfolk and Norwich.

He lives in the centre of the city with his wife Sue.